The Aztec and Maya Papermakers

VICTOR WOLFGANG VON HAGEN

DOVER PUBLICATIONS, INC.
Mineola, New York

Published in Canada by General Publishing Company, Ltd.,
30 Lesmill Road, Don Mills, Toronto, Ontario.
Published in the United Kingdom by Constable and Company, Ltd.,
3 The Lanchesters, 162–164 Fulham Palace Road, London W6 9ER.

Bibliographical Note

This Dover edition, first published in 1999, is an unabridged republi-
cation of the work originally published in 1944 by J. J. Augustin Pub-
lisher, New York.

Library of Congress Cataloging-in-Publication Data

Von Hagen, Victor Wolfgang, 1908–
 The Aztec and Maya papermakers / Victor Wolfgang von Hagen.
 p. cm.
 Originally published: New York : J. J. Augustin, 1944.
 Includes bibliographical references and index.
 ISBN 0-486-40474-9 (pbk.)
 1. Aztecs—Social life and customs. 2. Mayas—Social life and
customs. 3. Manuscripts, Maya. 4. Manuscripts, Nahuatl.
5. Papermaking—Mexico. 6. Papermaking—Central America.
7. Mexico—Antiquities. 8. Central America—Antiquities.
I. Title.
F1219.3.P3V66 1999
676'.22'08997452—dc21 98–51344
 CIP

Manufactured in the United States of America
Dover Publications, Inc., 31 East 2nd Street, Mineola, N.Y. 11501

To the most eminent authority on old papermaking,
Dard Hunter, this book, the outgrowth of our
interests, is respectfully dedicated

"... History is not a science, it is an art, and a man succeeds in it only by imagination."

Anatole France

"L'homme ... c'est un animal fou, c'est-à-dire qui se répand de tous les côtés, qui démêle tout en théorie et dans la pratique emmêle tout."

Rémy de Gourmont

Contents

Introduction

Through the entire evolution of civilization in all parts of the world, man's progress may be recorded in three distinct steps or stages, each extending through hundreds or even thousands of years. These predominant stepping stones in the growth of man may be classified under three broad headings: Speaking – Drawing – Printing.

The first of these evolutions – Speaking – has existed from time immemorial and constitutes the primary and fundamental form of expression. Prehistoric man early mastered a positive form of oral communication by employing guttural sounds that conveyed intelligible meanings among the peoples of primitive tribes. In the beginning there was no method of transferring ideas save through the human voice.

In the second stage – Drawing – a method of communication was evolved that raised man's intellectual powers to a vastly higher plane than could have been achieved through the mere utterance of sound. Even the crudest portrayals of objects and the most embryonic signs, symbols and hieroglyphs required unprecedented ingenuity and facility, involving skills unknown throughout the word-of-mouth epoch. A pointed drawing stick had to be devised and guided by hand so that the desired characters or emblems might be scratched in simple outline in the ocean sands; or a cutting tool provided for incising pictures upon the inner walls of caves, such as the ancient bisons of the Altamira caverns. Long after the period of drawing in the sands and upon the walls of caves, came the use of the more workable materials such as wood, metal, stone, clay, leaves, bark, papyrus,

and parchment as basic surfaces upon which to incise and inscribe hieroglyphs and characters, each of these unwieldy substances, for want of a more suitable and adaptable material, faithfully fulfilling all requirements through the centuries. Then, in 220 B.C., the Chinese savant Meng T'ien invented the camel's hair brush, an innovation that not only revolutionized the writing of Chinese characters, but was instrumental in the development of woven cloth as a writing material, a substance which, along with the papyrus of Egypt and the parchment of Asia Minor, made possible the first form of book, the manuscript roll.

The rapid development of calligraphy by archaic scholars and their spontaneous adoption of the camel's hair brush and fluid pigment called for a writing substance that was cheaper and more practical than woven textile. This urgent need for a totally new writing surface inspired the Chinese eunuch Ts'ai Lun, in 105 A.D., to proclaim his marvelous invention of true paper, a thin, felted material formed upon flat porous moulds from macerated vegetable fiber. With the advent of paper, the art of calligraphy, as originally conceived by Ts'ang Chieh, had its real impetus, and brush-writing, as a method of recording history and setting down accounts, was destined to supersede all other methods for the following six hundred years.

The third step in the development of civilization – Printing – was long retarded. It was not until 770 A.D. that the first text printed upon paper was finally completed. While this original printing of Empress Shotoku's million *dharani** took place in Japan, its accomplishment was, nevertheless, of Chinese conception and made possible only through Chinese ingenuity and influence.

Following this development in the East, there arose in the Western Hemisphere another civilization which was in the first two stages – for it never reached the

* Buddhist charms. They were block-printed in the Sanskrit language, in Chinese characters, and placed in various temples. Some of these examples of "the world's oldest printing" are still in existence.

third — almost the counterpart of the Asian. The Aztecs and the Mayas developed their initial modes of expression in the same natural sequence as the Orientals: first, speech; then stelae, carved with graceful hieroglyphs and the features of Mayan deities; and finally they evolved, by their own adroit methods, the fabrication of paper and its eventual use for inscribing the sacred codices by means of liquid pigment and stylus.

It would appear that regardless of the isolation or distance of one continent from another, or the remote origins of peoples, the pattern of man's progress developed everywhere in the same way; the steps involved in the growth of civilization were almost identical.

Although we may compare the pursuit of knowledge and craftsmanship among the Aztecs and Mayas with that of the Far East, it must be borne in mind that the various achievements of China and other Asiatic countries had their contemporary historians who recorded them almost as they took place. For example, in China the invention of paper was well documented by Fan Yeh in the *Hou Han Shu,* while in Japan the inception of block printing upon paper during the period of Empress Shotoku was definitely established and authenticated in the *Shoku Nihongi,* a history of Japan covering the period from 704 to 791 A.D. We have also the great work of Marco Polo and the later informative writings of Sung Yinghsing, Jihyoe Kunihigashi, Seichiku Kimura, and many other lucid technicians. In studying the dexterous accomplishments of the Aztecs and Mayas, however, we have no such literature to turn to; if any contemporary descriptions of the techniques of their handicraft ever existed, they have long since disappeared. Therefore, a history of Aztec and Mayan paper and papermaking involves far more research, patience, and time than a similar recording of the invention of papermaking and printing processes in the Orient. For this reason the history of ancient American papermaking has long remained unwritten.

For many years, while occupied with investigations into ancient and modern

papermaking in Asia and Europe, I have been mindful of the desirability of an authoritative history of primitive papermaking in the early civilizations lying south of the United States. Almost forty years ago it was my unique privilege to live among the Otomi Indians in the village of Cholula, Municipality of Tianguistengo, District of Zacualtipan, Hidalgo, Mexico; and there I had the rare opportunity of watching these primitive workers fabricate their coarse, broadformed paper which, after being dried in the sun, was cut into grotesque images for use in religious rites. This aboriginal craft still exists, and I am gratified to have devoted several pages to Otomi Indian paper in my book dealing with the beaten-bark *tapas* of the Pacific Islands, published in 1927. Shortly after the distribution of this book, Primitive Papermaking, it was my good fortune to receive a letter from Victor Wolfgang von Hagen in which he expressed such interest and understanding of ancient papermaking in Latin American countries that I was at once convinced that, should a book on the papers of ancient America eventually be undertaken, von Hagen was undoubtedly best qualified for the laborious task. During the decade that followed our first acquaintance through correspondence, von Hagen wholeheartedly carried on numerous ethnological and zoological expeditions in Mexico, Central and South America, from the headhunters of the Amazon to the burned hills of the Galápagos Islands; many books and articles have been the fruit of his widespread activity. In my own researches during this same period, it has been my province to record the craft of papermaking in the Far East. Through these eventful years both von Hagen and I have never lost sight of the desire for the ultimate compilation and publication of the present volume, and it is needless to say that its long-sought completion is a source of extreme satisfaction. The prodigious amount of research in old and modern manuscripts, books, and records, and the perseverance in the unraveling of detail that the writing and illustrating of this book have entailed, are obvious; the work by von Hagen has been a labor of love. I know of no other historian who could have

accomplished such a thoroughly exhaustive and satisfying treatise on the subject of Aztec and Mayan paper; scholars of the present day, as well as students of paper for generations to come, will be indebted to Victor Wolfgang von Hagen for his painstaking and comprehensive achievement.

Dard Hunter

Dard Hunter Paper Museum of the Massachusetts Institute
of Technology, Cambridge, Massachusetts
March fifteenth mcmxlii

Foreword

THIS IS the story of primitive American papermaking and its place in the Aztec and Maya civilizations. It has not been easy to gather the material; those who have made these civilizations their sphere of interest will readily understand why: the physical evidence of primitive papermaking is meager, and the existing comments on the subject, obscure and contradictory. Of the thousands upon thousands of paper sheets and paper rolls that the early American craftsmen manufactured, and that were formed into books, maps, records, official messages, and tribute rolls, there are extant only three complete Maya codices (the Dresdensis, the Peresianus, the Tro-Cortesianus), and scarcely more than a score of Aztec codex-fragments. These lie scattered in libraries, public and private, throughout the world.

Nor is there much help from other sources. The Spanish chroniclers, Martire, Herrera, Oviedo, and Torquemada; the matter-of-fact *conquistadores,* Cortés, Díaz del Castillo, and Gómara; the god-intoxicated friars, Landa, Motolinía, and Sahagún tell us no more about this primitive American paper than will fill two sheets of foolscap. Faced with these lacunae, the writer was forced to work in various departments of science to obtain answers to the conundrums: Who were the papermakers? How did they make the paper, and from what plant or plants? And finally, what part did paper play in their civilizations? The chemical laboratory has supplied one part of the answer, the microscope another; botany and botanists have helped immeasurably; ethnological research by the author in Mexico, Central and South America, and by others in Micronesia, has suggested avenues of approach; all this, finally, has been supplemented and fused into narrative form with material found in the literature, ancient and modern.

This has not been the unassisted task of the writer; the specializations of schol-

ars, the eyes, the ears, the hands of many, have made this book possible. Señor don Hans Lenz and Miss Bodil Christensen, both of Mexico City, visited the Otomi papermakers, collected the primitive paper which forms part of this book, took the photographs, and confirmed the names and species of the paper trees. R. S. Pittman, of Morelos, spurred by an interest in the paper-search, made trips to photograph the pre-Columbian papermaking villages of Tepoztlan, Itzamatitlan, Amacusac, and Amatitlan, and in the United States, Dr. Paul C. Standley, of Field Museum, Chicago, and Dr. Ralph Roys, of Tulane University, assisted in the botanical phase of the work, while in the important details of geography I had the valued criticism of Dr. Carl Sauer, of the University of California, who minutely went over the first drafts of the manuscript. Dr. George C. Vaillant and Dr. J. Alden Mason, both of the University of Pennsylvania, and Dr. Robert Redfield, of the University of Chicago, have gone over the text, suggested changes and supplied details which have clarified many obscurities in the Aztec and Maya cultures; and long before the holocaust of war descended upon the world, Dr. Rudolph Schwede of Dresden, who pioneered the chemico-botanical investigations of the fibers of pre-Columbian codices, graciously permitted me to make use of his findings. And yet, despite all this assistance, the book would have remained unwritten, were it not for the encouragement of Dr. Dard Hunter. During the last decade we have exchanged many letters, collections, and notes on the subject of Aztec and Maya papermaking, and so much has he given me that I am almost forced to the conclusion that it is he who should have authored it. But Dard Hunter, the most modest and self-effacing of scholars, insisted that I should be the one to tell this story; thus, I have done so — with misgivings. Yet, so that it shall not be regarded as wholly mine, I have dedicated this, the story of Aztec and Maya papermaking, to the most eminent authority on primitive paper and one whom I am deeply honored to call my friend — Dr. Dard Hunter.

A word more about the plan of the book. The historical aspects of paper are

bound up inextricably with the intellectual development of mankind, whether it be among the Mayas or the Arabs. Judged by itself alone, without reference to the culture that it nurtured, the story of Maya and Aztec paper is meaningless. To give it its full significance, its human, dramatic and cultural values, we must go back to the earliest origins of paper in remote times and widely separated regions and follow its migrations. We must trace its vital relation to the individual and social life of peoples, its functions and its influence in the rise of thought, knowledge, customs, skills – in short, civilization; that is the raison d'être for the preludes and interludes which vitalize the more specialized aspects of the book; and these form as integral a part of the paper story as the descriptions of its processes and the involved botanical references. And, too, they illustrate the historical interaction of different phases of the evolution of paper when two of the civilizations, European and Amerindian, met.

Then when paper, by means of the renaissance which it helped to create, brings the first Europeans to America's shores, we have at first a scene purely Aztec in character, centered around paper as an article of tribute. With the establishment of a European bridgehead at Vera Cruz, the paper-world of the Amerindians comes into contact with the paper-world of Europe, is conquered by it, and, as a result of the conquest, will eventually cease to be a living force. It shall then enter into the phase of botanical classification, chemical analysis, and historical interpretation. And so in the final chapter, we see paper in its brilliant pagan setting before the onrush of the *conquistadores* who, with Hernán Cortés as their standard-bearer, engulf the Aztec and his world.

Santa Monica
California
1943

Paper and Civilization

IN THREE theatres of the world remote from one another – Asia, the Mediterranean, and Middle America – paper, in different forms, played its role in the intellectual evolution of peoples. Papyrus, the cultural paper medium of the Mediterranean, is well known. Equally well known is paper, true paper, made by the Chinese from the disintegrated fibers of the mulberry. Of the paper of the American civilizations, the *huun*-paper of the Mayas, the *amatl*-paper of the Aztecs, almost nothing is known. Paper, true paper, invented by the Chinese, has a definition which is classical: paper is a thin tissue composed of any fibrous material whose individual fibers first separated by mechanical action are then deposited on a mould suspended in water. It was the Chinese who devised the paper mould, an instrument capable of picking up the macerated fibers and allowing the water to escape, leaving the interwoven fibers in a felted mass. This, when dried and pressed, became "paper."

Yet, great cultural heights have been reached by civilizations without true paper. The Egyptians and the Syrians manufactured papyrus; the Mayas fashioned their *huun*-paper; the Aztecs their *amatl*-paper. In default of the technique of true papermaking, these civilizations developed writing surfaces on which they were able to transmit knowledge from one brain to another, to compile records, to preserve traditions and to develop ideas other than by oral communication. So with paper and writing, they freed communications from the limitations of the time-space factor, and by so doing an epochal step in human progress was made; even though their paper was technically not true paper, it performed all the cultural functions of true paper.

There is no precise period in which we can place the dawn of American culture or any indisputable moment when paper begins to play its role in Middle America. We do know, however, that in the fifth century A.D., when the civilizations of Europe, the Mediterranean, and China were in large part breaking up (and facing centuries of cultural anarchy), the Mayas were reaching the apogee of their development, for in the course of a few hundred years, they had reared in the jungle the stone cities of Copán, Quiriguá, Ixkun, Holmul, Nakum, Yaxchilan, and Palenque. Roads were carved out of America's green mansions; trade and commerce spread far beyond the limits of Mayadom. Art and religion, inextricably bound up with tribal government, grew with it in complex elaboration. Astrology became highly developed as well as their knowledge of astronomical periods; the discovery of a permutation system of names and numbers produced a complex calendar. And the Maya astronomers even discovered the concept of zero. As this abstract mental activity increased in volume and subtlety, the Maya required more involved and flexible hieroglyphic symbols to record it, and these, when perfected, helped not only to extend their mnemonic processes, but created as well the beginnings of a literature. Carving these hieroglyphics on stone without the aid of metal instruments eventually proved impractical and in their ceaseless search for a smooth, easily handled material on which to write they discovered that the bark-cloth tunics with which they covered their persons could, when sized, be used as a surface for their hieroglyphic symbols. After this discovery, bark-cloth tunics ceased to be used exclusively to cover Maya bodies; they had evolved into paper. And this paper, anonymously and communally perfected by the Mayas, they called *huun*, a "paper" far superior both in texture and durability to Egyptian papyrus.

Paper, in a sense, gave permanent content to Maya civilization. It helped them

to perfect the intricacies of their calendar which in turn assisted their agriculture. It assisted in the development of hieroglyphic writing, which permitted them to augment oral tradition. In the role of sketch-pad, *huun*-paper doubtlessly played its part in working out the plans involved in the construction of gigantic temples and palaces, as well as in the elaboration of decorative architectural detail. And finally, *huun*-paper had its final cultural evolution in the fashioning of folded books on which the astronomer-priests inscribed, in eloquent painted pictographs, the accumulated knowledge of the Maya people. These books they housed in stone buildings guarded and protected through the centuries.

The Mayas made these hieroglyphic charts for centuries, even through the period of decline. When Maya civilization revived again in the tenth century and coalesced with Toltecs who brought with them the cult of Quetzalcoatl the Feathered Serpent, the Mayas had already begun to fold their *huun*-paper into book form. In this period they produced a sacred almanac of forty-five pages still extant and known as the Codex Dresdensis. This remarkable polychromic book, its characters and figures set down by some anonymous astronomer-priest of Mayapan, was fashioned somewhere between 900 and 1100 A.D.

When the Mayas entered upon the long period of decline which led to a decadence lasting from about 620 to 980 A.D., the Toltecs of the high Mexican plateau became the dominant cultural element in Middle America. For the Toltecs were the masterbuilders of Teotihuacan, of Tula and Cholula. We know little of their history except as it is revealed in the ruins of their superb architecture. The Toltecs assimilated and improved the Mayan techniques of papermaking and writing, for if their history can be credited, they had by the seventh century an encyclopedic Teoamoxtli,* a "divine book" compiled at Tula in the year 660 by the astrologer, Huematzin. Toltecan writing had, it seemed, advanced sufficiently

* Amoxtli—The Toltec word for *amatl*-books.

for them to record a "History of Heaven and Earth," a cosmogony, a description of the constellations, a division of time, a record of the migrations of the Amerindian nations, a mythology and, if tradition may be credited, a "moral philosophy."

Throughout this misty epoch, the Toltecan hieroglyphic records accumulated. Partly with magic, partly with technics, the Toltecs sought to dominate their environment in their conquest of nature. Yet they too, like the Mayas before them, went into eclipse and the Aztec nation between 1100 and 1300 appeared on the cultural horizon.

According to their own written traditions, the Aztecs migrated from the North to the lake regions of the Valley of Mexico in 1168 and founded their island city of Tenochtitlan in the center of Lake Texcoco. Then by rapine, bribery, and statecraft the Aztecs enlarged their realm far beyond the confines of the Valley of the Anahuac. Just as the Romans took over Greek trade and culture, so did the Aztecs take over the Toltec tribal economy and culture. Under their sway, much of Middle America was systematized. Trade and conquest, an inseparable union, expanded together; tribute was levied upon conquered tribes. To keep a record of all this called for precisely written tribute-lists. And so as in no other primitive American civilization there was an insistent demand for paper.

Paper fashioned into rolls thirty feet long was used, as by the scribes of ancient Toth, to record the accretions of conquest. Paper, as with the Chinese, took on a religious and ceremonial character. Paper, folded like a miniature screen, formed the sacred books, called *tonalamatl* (which were preserved in library form in the Aztecan archives at Texcoco). And finally, paper became itself an important article of tribute. In one of the most famous of the tribute-charts of Montezuma II, the Codex Mendoza, we find this significant item:

"Twenty-four thousand resmas of paper are to be brought yearly to the storehouses of the ruler of Tenochtitlan."[1]

Twenty-four thousand resmas is 480,000 sheets by the Aztec system. Judged by

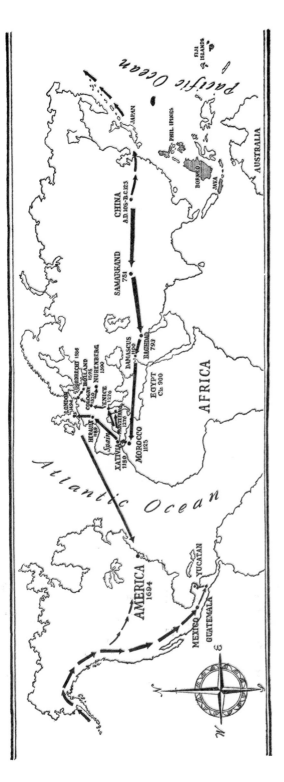

The Path of Paper

The path of paper *begins in China* before the advent of Christ. It *travels through the east to Asia Minor, across the Mediterranean into Europe.* Spain is the first European country to produce paper, France the second. Everywhere paper becomes the fibrous messenger of the new Gods of learning. The first paper mill came to America in 1690–4 under the firm of Rittenhouse in Pennsylvania. But paper-making had come directly *to Mexico from Spain* as early as the 16th century. In 1580 *at Culhuacan, near Mexico City, the first European paper-mill was established in the New World.*

The broken arrows in the path of paper indicate the now-accepted route of the proto-mongolic peoples to the land of America. The line of invasion continues, so far as paper is concerned, to the plateaus of Mexico and the lowlands of Middle America. There in some remote period, perhaps even before the crude beginnings in China, the Mayas made the first paper from beaten fibres of the Mulberry family.

Drawn from the notes of Victor Wolfgang von Hagen by Antonio Sotomayor.

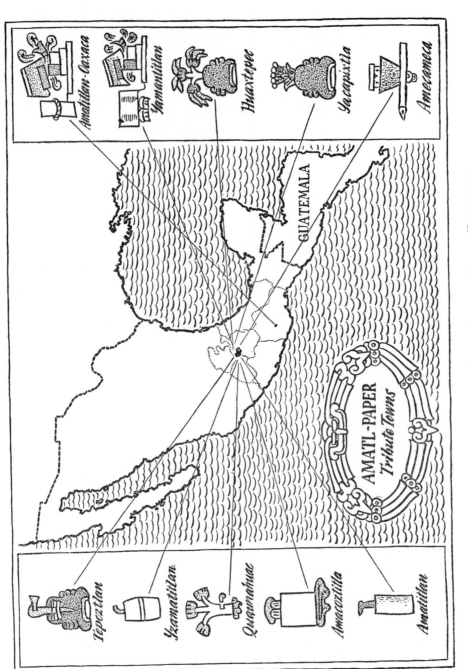

MAP OF THE AMATL-PAPERMAKING VILLAGES TRIBUTE IN PAPER TO TENOCHTITLAN

On the margin of the map are the rebus-drawings and the heraldic shields of the paper-making villages. In some of the villages, notably Itzamatitlan, Amacoztitla and Amatitlan, the amatl-paper symbol is used, implying that that village was primarily known for its paper; all the others are equally famed for paper, but in addition produced other artifacts in primitive Indian economy.

Drawn from the notes of Victor Wolfgang von Hagen by Antonio Sotomayor.

the standards of a primitive civilization, this is an enormous amount of paper, enormous even though the Spanish word *resma** is only an expression which fortuitously coincided with the Aztec numeral *pilli,* twenty.[2]

So advanced the Aztecs. Yet they were by no means unique. The tides of cultural influence ebbed back and forth among all the tribes of Middle America and out of this flow what first had been the exclusive property of one tribal group became the cultural currency of all. Whether Maya, Toltec, Zapotec, Totonac, or Aztec, all, by the fourteenth century, had hieroglyphic writing, all were papermakers, all had histories, almanacs, and sacred calendars in book form.

But this cultural evolution was not destined to continue. For across the ocean another civilization, renascent Europe, had emerged. It, too, had produced books which captivated men's minds. Men read and dreamed and sought for new lands and empires beyond the confines of Europe. When, at last, the ships of Cristóbal Colón sailed out upon the vastness of the Atlantic, it was in the direction of Middle America. Ten eventful years passed, and three voyages since that fateful year, 1492, before Colón guided his caravels in 1502 on his last voyage and made contact with the outposts of Mayadom.

* "Ream" is adapted from the Spanish *resma* which is derived from the Arabic *rizmah,* a bundle, especially a bundle of paper.

The Paper Tribute

THE tumultuous waves of the Conquest were about to break upon the American continent. Rumor, sniffed as it were on the breeze, sensed by sub-human faculties, travelled over the jungles; it radiated in thrilling waves from the Maya temples; it spread from tribe to tribe as fast as words could tumble from the mouths of Indians: "men with white faces and black beards, with belching fire-sticks, have come from over the sea."

What had happened was this: The Mayas had come face to face, on July 30, 1502, with the caravels of Cristóbal Colón on his fourth and last voyage at the island of Guanaja* in the Bay Islands which lie in the Gulf of Honduras. No sooner had the men of Colón gone ashore than they were met by "two . . . Canóas — as long as a galley and as broad as eight feet — in the middle, an awning so that neither the water of the sea nor that of the sky could wet them." The goods they brought [for they were merchants] were cotton blankets, gaily colored . . . sleeve-less shirts, wooden swords, studded with obsidian . . . knives, copper hatchets . . . copper bells. When the admiral asked the Indians whence they came, they answered, "Yucatan."** This the notary duly entered in the ship's log. This meeting, too, also deeply impressed the Mayas. As soon as they returned to their stone cities on the "Yucatan" peninsula, the news of this historic meeting with "black-bearded men in great ships" boiled over from the councils and went over the

* Known today as *Bonaca.*
** "Yucatan": When the Indians were asked whence they had come, they were supposed to have replied, "Yucatan" – ("I do not know.").

trails to the people and to the merchants, and moved from tribe to tribe. Up went the astounding news to the Mexican plateau, to an Aztec outpost. There at the dictation of some chieftain a scribe (so that Montezuma could understand it the better) gave substance to the rumor by drawing it partly in pictures and partly in hieroglyphics. When it reached Tenochtitlan, the council could read: "The Year 10 Tochtli, year ten of the Rabbit (1507),strange bearded men in large boats have come from over the sea." So was set down an hieroglyphic interpretation of an event which was vaguely sinister, an unhappy augury for Montezuma II, who had just come to power as *Uei Tlatoani* (successor to Ahuitzotl), senior Lord of Tenochtitlan.

That was the first time they had heard of these strange men, but as the years went by, rumors continued to float with terrifying persistence from the shore to the mountains. It was known to the Aztecs when Colón landed at Guanaja, and when Yañez Pinzón and Juan Díaz de Solís skirted the shores of Yucatan. As yet no Aztec had seen the strange visitors; all that was known about them came from the hieroglyphic charts and from the floods of rumors that rushed over the waters of Lake Texcoco. The evil augury of their presence and their mysterious movements penetrated to the innermost recesses of Mexico, haunting the dreams of the rulers and the lives of the humble with nameless forebodings. None could say who they were, whence they came, what their purpose was, what measures could prevail against them – not the necromancers nor the priests nor the elders of the tribes.

The end of a cycle of fifty-two years was at hand. It was time to prepare for the New Fire Ceremony in which the old altar fires which had burned perpetually during this period would be extinguished, and the kindling of the new fire, symbolizing a new grant of life, would take place. After all the fires were extinguished, there would follow the *nemontemi,* the five "empty days," during which no one in all Aztec-controlled territory was allowed to kindle or raise a flame. The fire was dead. Would the gods grant new life? Always, at these times, there

was the fear that no new flame would arise, that, surrounded by unimaginable horrors, all life would cease. During those five days of suspense, all gave themselves over to prayer and fasting. Pregnant women were shut in the granaries, lest they be changed into ferocious *tzitzimime* (wild animals), and children were marched up and down and kept awake, for fear that sleep on that fateful evening would turn them into rats. Tense and trembling, all awaited the catastrophe – or the release. If the world survived, the solemn ceremony of lighting the new fire would be performed, to be followed by days of varied festivities.

This year a new element of dread mingled with the traditional terrors – the haunting presence of the strangers. To appease the gods and avert the evil, the celebration must be the most spectacular and lavish ever known. To implement and adorn it and pay for it, tribute must be collected far and wide from all the vassals of the Aztecs. The *calpixque* (tribute collectors), with their armed knights, streamed forth from the capital over the well-kept *tezontli* roads that meshed all adjacent tribes to the will of Tenochtitlan. Moving southward, they reached the chief city of the Tlahuica, conquered half a century before by Montezuma I. All the villages that lay out from Quauhnahuac* were tributaries. The practice of extracting tribute from a conquered tribe had grown so much a part of Aztec economy that tribute-houses were placed on the boundary of the tribute-territory in order to facilitate the proceedings. A day's journey from the island capital of Tenochtitlan brought the collectors to Tepoztlan. It lay at the focus of a parabola of mountains on the northern escarpment of the plateau that rose out of the Valley of Mexico. They crossed through pine-studded, lava-strewn hills over which blew frigid winds, and dropped again to the valley where Tepoztlan lay in a constellation of Tlahuican villages, all tributaries to the Aztec lords.

* Now Cuernavaca. It was called Quauhnahuac (Eagle of the Nahuas). The Spaniards turned it into Cuernavaca (Horn of a Cow).

The tribute collectors arrived wrapped in richly embroidered robes, their shiny, heavily-greased hair tied high on their heads, a curved stick in the right hand, a nosegay of flowers in the left; protected against the insistent bites of *jejéns* (flies) by the waving feather fans which their servants swished at their sides. About them trotted a subservient crowd of local chiefs. Without for a moment relaxing their haughty miens, the *calpixque* entered the tribute-house to eat the meal prepared for them by the terrorized Tlahuica. While they ate, a scribe pulled out the tribute-charts and read out to the village dignitaries the sum and substance that must be paid.

For weeks the people had toiled to collect the articles the Aztecs required. On the grass-mat *petates* in front of the tribute-house they had already piled feather mantles, gourd-shell *jícaras,* axes of bronze, knives of the black volcanic glass, obsidian, yards of cotton cloth, and rolls of *amatl*-paper. Of this paper they were forced to yield 24,000 rolls every six months. Already it was growing harder to provide their quota, for the wild fig tree from which it was obtained was growing scarce. But this year, more than ever, the tribute collectors insisted on the full amount. Vast quantities of paper were needed for the celebrations that would follow the New Fire, glorious rebirth of life. The populace would want paper, tipped with rubber, to burn. Paper was required to make the *tonalamatl,* the books containing the sacred calendars; paper must be at hand to record the new glories of Montezuma II.

The tribute of *amatl*-paper, like all other tribute, was the natural outgrowth of the Aztec system. Since 1325 A.D. the Aztecs had carried on a form of commercial rapine that had soon made them overlords of much of the Mexican earth. Called Tenochca, they began as a migratory tribe from the north, took refuge on two islands in Lake Texcoco, and there for some years lived a miserable life among the reeds. Then they began to extend themselves. Limited by lack of

land, they developed, at first, neither agriculture nor crafts on a large scale. Their system – and it was a system – was based on predatory raids on neighboring tribes. In battle, killing was avoided, the captured warriors being brought to the island-city of Tenochtitlan as hostages against the payment of tribute consisting of the products of the regions whence they sprang. Since the captives had strong blood ties with those who remained behind in the native villages, the conquered could be expected to submit to the Aztec demands to prevent the sacrifice of their kinfolk. Much of Central Mexico had thus come under the Aztec sway, including the territory of the Totonacs, the Zapotecs, the Mixtecs, and even, perhaps, the Mayas in Tabasco.

Land and agriculture made up the basic pattern of all the Mexican cultures. Land was assigned to the people by the tribal elders, the heads of the *Calpulli,* the geographical clans,[1] and the product, the usufruct of the land, belonged to those who had worked it. If unworked for two years, the land reverted to the community and was re-assigned. Much of the work was done communally. The people had to provide for the maintenance of the temples, the priests, and the religious services – and when a village was under tribute, all must work to provide it.

The Aztec civilization was a dynamic composite of many elements, some independently developed, some incorporated from the tribes that succumbed to it. It soon ramified into the governmental complexity of a populous and highly organized city-state[2] as the Aztecs extended, systematized and administered tribal adherence.[3] Other Mexican tribes, to be sure, had been more advanced culturally; they had invented writing, the calendar, paper,[4] but it was the Aztecs who, seizing upon these products and skills, welded most of Mexico and parts of Central America into some semblance of economic synthesis. Tribute and trade thus became the basis of Aztec society. The *pochteca,* the merchant class, quickly followed in the wake of conquest, extending the might of empire by trading and

spying, and the semi-annual collections of tribute recurred as regularly as the solstices.

Now, at Tepoztlan, the collectors sat while the elders of the people displayed their samples of tribute and helped to record them. Among the most valued was the *amatl*-paper. Already, worming its way along the narrow road, appeared a long line of Indians – *tlamemes* – the carriers – capable of carrying twenty-two pounds for twenty-two miles – drawn from all the neighboring villages to transport the paper tribute to Tenochtitlan. They moved slowly, their heads bent slightly earthward, held rigid by the flat *mecapalli* (strap) that stretched across their foreheads to clamp the cargo on their backs. They were dressed simply, a breech clout – *maxtli* – wound about the waist, their long black hair hanging in a single braid. The rolls, pile upon pile, pyramiding above them, seemed on the point of engulfing them. The long human line came to a stop. The leader, approaching the agents of Montezuma, touched the ground with his fingers in a stiff salute.

One of the agents, with swirling embroidered robe and squeaking jaguar-skin sandals, stepped forward to inspect the precious freight. He walked along the line, stopping occasionally to pull loose a large white roll, untie the cord that bound it and let it uncoil its entire length of fifteen feet. He examined it closely for imperfections; then, satisfied, walked on to repeat the performance farther along, leaving to others the task of replacing the paper cylinder on the carrier's back. He was accompanied by the official scribe, who squatted, now and then, over a large paper roll, recording the transaction. First he placed the emblem of Tepoztlan,* a moun-

* "Aztec writing," Vaillant points out, "was pictographic and was arriving at the stage of syllabic phonetics (which is an important part of the hieroglyphic writing of Egypt) . . . color, position, puns, and abbreviations all contributed to recording sounds by these means. Conventionalized signs, like footprints to show travel or movement, a shield and a club for wars, bundled corpse for death, gave simple connotations of action."

tain with a copper axe stuck into it handle first; then the tribute-symbol of paper, a paper roll tied with braid; then attached to the roll he drew a pouch, signifying the number eight thousand.*

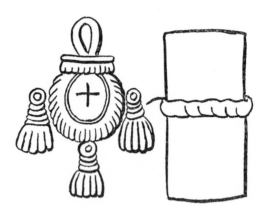

The tribute-symbol of paper tied with a braid and attached to it a pouch signifying the number 8,000. Eight thousand rolls of *amatl*-paper.

Now the carriers began to move slowly down the *maguey*-bordered road. Behind them came still others, dressed like them and like them laden with paper. But this paper was packed, not in rolls, but in sheets of a yellowish color, folded screenwise. While the bundles of sheets were being counted, the scribe drew the rebus of Amacoztitlan, the village from which the sheets had come. First he drew an almost square sheet of paper and colored it yellow; below this he placed the symbol of water, which indicated Amacusac, the yellow river; above, the suffix *tlan* (the place of), the hieroglyph for which consisted of two incisors. It could easily be read: Amacoztitlan, the-place-of-the-yellow-paper. Since these drawings were records which were to be filed in a special apartment in Montezuma's palace, watched

* Eight thousand was represented by a copal pouch. The numerical system was vigesimal, that is, they counted by twenties (the sum total of toes and fingers), as we count by tens. A dot or a fingertip was the sign for the numeral one; a flag, for 20; a feather meant 400, etc.

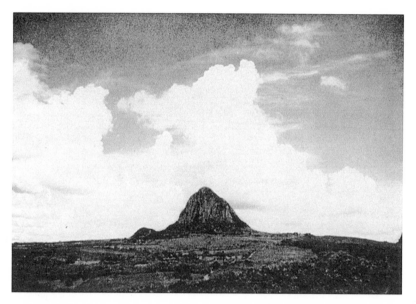

The Otomi Indian country, Cerro de Postectilla, Puebla. Beyond the slope into the valleys are the homes of the Otomi papermakers.

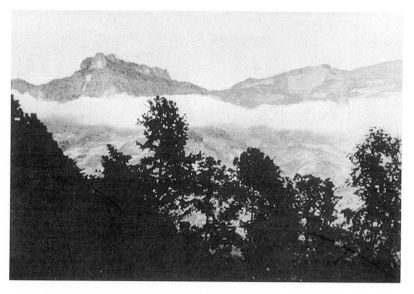

San Pablito, Puebla, the region of the Otomis.

over by the elder called Tapia, the keeper of accounts and tributes, the meaning had to be clear.

The yellow paper sheets, too, were duly examined and registered. Then the natives of Amacoztitlan walked forward to join the long line of carriers ahead.

There was another kind of paper – fashioned in sheets. These were tribute from the town of Amacoztitlan. The scribe drew an almost square sheet of paper, colored it yellow, below this he placed the symbol of water, painted blue, above it the suffix *tlan* – two incisor teeth. It read: Amacoztitlan: The place of the yellow paper sheets.

At a command, the Aztec soldiers reposing on the ground sprang up, shouldered their obsidian-tipped spears, flanked the carriers, and the line moved forward. Mile after mile it went along the road of *tezontli* brick, past houses and villages, down to the flowering marshes of the Valley of Anahuac, and over the causeways to the island city of Tenochtitlan.

<p style="text-align:center">* * *</p>

So, on the eve of its doom, the Aztec empire repeated its pattern of conquest. Tribe upon tribe had fallen before its plumed knights; tribe upon tribe, with

mounting resentment, paid tribute of inestimable value to the people of the inland lakes. Merchants followed the conquests and Aztec commerce had penetrated as far south as Nicaragua. Manufacture and trade played an increasing part in Aztec economy. The arts of husbandry, of weaving, pottery, metallurgy flourished — great aqueducts and causeways were flung across the lakes; gigantic temples rose, centers of political and military power; libraries were established. At Texcoco, as at Alexandria of the Ptolemies, a stone building housed thousands of manuscripts, religious, magical, and historical.

On the eve of 1519 the Aztec stood on what may well have been the threshold of a new epoch. Wooden and clay stamps were used increasingly for applying decorative motifs to pottery and cloth in the mimic of mass production. Some stamps were even being made of metal. The hieroglyphic writing, already partly phonetic, might in time have reached some semi-alphabetic development. All the ingredients of modern civilization were there, writing, paper-formed books, a literature, and paper in abundance, 480,000 sheets of it pouring yearly into Tenochtitlan. These same elements, whether in China, Egypt, or in Mainz, Germany (whence issued the first book printed with movable type), were everywhere the forerunners of literary vigor, of invention and of cultural renaissance. In the primitive Amerindian world, still bound to the earth, still based on the use of the stone celt, cultures would have . . . but it is useless to speculate what it might have been, for — moving on the currents of the gulf stream, snaking north along the coast was a tiny fleet of sails.

Hernán Cortés had arrived.

The Twilight of the Gods

At cintla, on the shores of Tabasco in 1519, the Indians at long last came face to face with the apparitions that had haunted their lives for more than two decades. They had brushed the year before with the Spaniard Grijalva; now they faced the soldiers of Hernán Cortés, the strangest and most terrifying human fauna that any Indian had ever encountered. They watched as the Spaniards, weighed down with armor and ordnance, struggled through the quagmire of the river's estuary. They allowed them to gain a flat plain – then they struck.

There was a flash as swift as lightning as an obsidian-tipped spear shot through the air. It struck the breast-plate of Cortés with the clang of a clapped bell. In a moment the air was split with battle cries. Arrows, stones, spears, rattled like hail on the armor of the *conquistadores*. Under this barrage the Indians advanced upon them, moving to the rhythmic sound of trumpeted sea-shells. The Spaniards seemed almost within their grasp when, with a roar like a volcano blowing off its serrated top, the Spanish harquebuses belched death into their charging ranks. The Indians toppled like ninepins. Before they could re-form, the cavalry poured down upon them from the rear, and doubly bewildered by beast and gun, the Tabascans fled. It was a notable event; the King's Notary, Diego de Godoy, under the date of March 12, 1519, recorded it.[1]

Cortés offered peace to the Indians – peace, that is, under the principle of *cujus rex eius religio* (since the service of God and King were one and the same) and he placed in the hands of the awe-struck chiefs a few worthless glass ornaments as a gesture toward the *Pax Cortesiana*. Contact was established. Weeks of nego-

tiations followed. Gifts were exchanged. The Indians brought cotton robes, feather mantles – and gold, thinking thus to satisfy the invaders, who would now depart. Had they but known then what they were to learn so thoroughly later that "the Spaniard is troubled with a disease of the heart for which gold is the only remedy," they might have tried other tactics.[2]

Montezuma, on the castellated heights of Mexico, was kept informed by his agents, spies, and runners, of every movement of the white, black-bearded men. For over a decade strange happenings – earthquakes, a tidal wave in the great lake of Texcoco, comets, mysterious fires, and voices wailing in the wind had pointed to impending catastrophe. The prophesied return of Quetzalcoatl was ever in his mind. He was deeply troubled, for he could not be sure whether the strangers were men or gods, and to act upon either assumption might be disastrous. He sent numerous delegations to placate and keep them at a distance, each more sumptuous in rank, clothing, and gifts than the preceding one – with friendly messages accompanied by a firm refusal to allow them to enter his capital. At last, at San Juan de Ulua, in Vera Cruz, the local governor of the Totonac nation, Teuhtlile, came with a delegation of nobles as the personal representative of Montezuma.

After food and mass, negotiations were carried on through "a double cascade of interpretations." Cortés spoke in Spanish to Aguilar, who had lived many years among the Mayas; Aguilar repeated his words to Doña Marina* in the Mayan language, and she, in turn, addressed the Aztec ambassador in his own tongue, Nahuatl. Cortés then received the ritual presents of the Aztec ruler. As the carriers deposited their loads on the rolling green savannahs of Vera Cruz, and the woven mats were piled with gold ornaments, featherwork, gem-studded boxes

* Doña Marina (so-named at her baptism), the famous Malintzin, or Malinche, of the Aztecs, a Mexican woman of high birth who, as a child, had been given by her stepfather to the Tabascans, was presented by them to Cortés, along with nineteen other young women and much gold. Through her intelligence, quickness, and loyalty to Cortés, she proved of inestimable value to him and became an important figure in the Conquest.

and masks, obsidian-tipped swords and lances, the scene was recorded in minute detail by the painter-scribe of Teuhtlile's retinue. Cortés watched the crouching artist fill his long paper with pictographs (for the information of Montezuma); men and horses, arms and armour were drawn, ships in the bay and cannon on the shore were put down. Cortés saw at once the political capital to be made from an illustrated manual of his military strength. He put his men and horses through their paces and ended by sending a cannon ball ricocheting over the verdure-splashed hills; all this the artist faithfully delineated.

The hieroglyphic chart performed its purpose. Within five days the envoys returned, this time with two additional nobles and gifts far exceeding all that had gone before: finer gold, more exquisitely worked; richer robes, more elaborately embroidered; pearls and jades set into magnificent ornaments. Among these gifts were two over which the Spaniards did not linger: two books, "brightly painted, which the Indians call *tonalamatl*," colored pictographs "books of the country," Bernal Díaz del Castillo³ tells us, "folded in the manner of cloth of Castille." They were curiosities, of course, but, compared with the real treasures, of little moment. Only Godoy, the King's Notary, paid any attention to them, and that was only because it was his duty to note down all the "gifts," for even conquest must be legal.

Among them were:

Firstly: A large wheel of solid gold with a monster's face upon it: 2800 *pesos d'oro.*

Item: Two collars of gold with precious stones.

Item: A pair of leather slippers in color much like the skin of pine-martens — sewn with threads of gold.

Item: In another box a huge head of an alligator in gold.

Item: Eighteen shields ornamented with precious stones.

Also: *Two books such as the Indians use.*

"Two books such as the Indians use"*. . . there it stood in the list of golden and jeweled objects, a good cross-section, so Cortés believed, of what the country would yield. He turned for a moment from "Indian books" and "golden collars" to forge the legality of his conquest: first, by establishing on those shores the Rica Villa de la Vera Cruz – the Rich Town of the True Cross – then, by drafting his famous "First Letter" to Carlos V which was dispatched to Spain with the gifts and the list in the keeping of his two *procuradores,* Alonso Hernández Puertocarrero, Cortés' friend and confidant, and Francisco de Montejo. They were selected to carry an account of what the army of Cortés had seen and done in the New World along with samples of the metal of a land ("that teemed with gold as abundantly as that whence Solomon drew the same precious metal for his temple"), four live Indians and the annotated list of presents which included the hieroglyphic books. So armed, the two *procuradores* set off for Spain.

Rivers of blood were now to flow.

Hernán Cortés burned his ships and set off toward Tenochtitlan for conquest and glory.

Pietro Martire and the "American Books"

Pietro Martire was the only man in Spain who paid any attention to the *"two books such as the Indians use."* For the Court was in a turmoil over "the happiest news which a Prince ever received – that of the discovery of New Spain and the great city of Mexico by Hernán Cortés."[1] It was impressed by the discovery even more than by the intrinsic value of the gold and the precious stones or by the delicate workmanship of the first fruits of conquest; even though, as Las Casas, who was an eye-witness of the presentation, says, "All who saw these things, so rich and so beautifully wrought and lovely ... were wrapped in astonishment and admiration."[2]

Pietro Martire alone was "wrapped in astonishment" over the books, which came into his hands after they had been registered December 5, 1519, by the Keeper of the Jewels. The emissaries of Cortés, immediately upon their arrival, had fallen into the midst of a bureaucracy torn by political feuds and personal hatreds. They had been guided to the *Casa de Contratación*, "a kind of Colonial-Office of Board-of-Trade contrivance,"[3] which was presided over by the dour-faced Bishop Fonseca, a warlike executive "whose advice smacked more of gunpowder and tar than of holy water."[4] Being of the party opposed to Cortés, he thundered that he "should have the two *procuradores* hanged" – but the opportunity slipped by, if there ever was one, and the two men, with their lists, came into the presence of the Italian humanist Pietro Martire d'Anghiera (called Peter

Martyr by the English), who assisted in the *Casa de Contratación*. As he ran his eyes over the items, he came to the following:

"*Mas:* dos *libros* de aca tienen los Indios:
 Seis piezas a pintura de pincel; otra pieza colorada con unas ruedas
 y otras dos piezas de pincel."[5]

"*Libros? Books?* These natives of New Spain have books?"

It came as a stunning revelation. He asked to see them, and when the Aztec books were brought to him by Juan de Ribera, who had accompanied the *procuradores,* Ribera was quick to explain that they were of little value, since they were "designed as patterns for jewelers and embroiderers." But this did not put off the learned Pietro. He had been to Alexandria, had seen the rolls of Egyptian papyri, and he felt little hesitation in placing the enigmatic characters of the Amerindians beside those of the Egyptians. Martire was an assiduous letter-writer, a confidant of grandees, popes, and monarchs, with a quick, intuitive mind which could cut through a maze of conflicting stories and theories and reach the truth. He was "one of the most trustworthy of contemporary witnesses" to the events that shaped the finding of the "newe worlde," and now we find him writing letters on his notable discovery: "The Indians of New Spain write in books."

His letters were "not necessarily confidential, but often handed around to local groups owing to their news value; and, thus multiplied by local Peter Martyrs,[6] the news spread all over Europe": "the Indians of New Spain have books."

"They do not," he wrote to Pope Hadrian, "bind them as we do, leaf by leaf; but they extend one single leaf to the length of several cubits,* after having pasted a certain number of square leaves one to the other with a bitumen so adhesive that the whole seems to have passed through the hands of the most skilful bookbinder.

* Cubit – Cubitum (an elbow) a unit of measurement – 45.73 cms or 18 inches.

And," he continues, "whichever way the book is opened, it will always present two sides written; and two pages appear, and as many folds, unless you extend the whole of it."

In this clear, precise description of an Aztec *tonalamatl,* the "books" of the Aztecs became known to the literary men of Europe.* Martire's interest did not stop there. He wanted to know of what substance the books were made and how they were manufactured. When he questioned the agents of Cortés and found they had witnessed its preparation, he pierced through their indifference and reached the conclusion that: "The leaves of these books, *upon which they write, are of the membrane of trees, from the substance that grows beneath the upper bark, and which they (the Indians) say is very scarce.* It is not like that found in the willows or elms, but such as one will find inside of certain edible palm trees, and which, resembling coarse cloth, grows between the intersecting leaves, precisely like network. To render it pliable they fill up those porous membranes with bitumen and stretch them to whatever form they please, and setting and becoming hard again, they cover them with gypsum. I, however, presume that *the paper which they* [Montejo and Puertocarrero] *have seen preparing,* was made with a substance that is only similar to gypsum, beaten and sifted into fine flour, and thus a substance is prepared upon which one may write whatsoever would occur to one, and erase it with a wetted sponge or cloth, and so prepare to use it again."[8]

So, from Pietro Martire, the most trustworthy chronicler of these world-stirring events, we learn that American books and paper were made from "the membrane of trees . . . that grows beneath the bark."

Martire's statement is very important, not only because it was the first observa-

* Martire wrote also to others about the books of the Americans. In a letter to "los Marqueses de Velez y de Mondejar" he says, "Quisiera hablar al presente de la grandeza de aquellas ciudades, del orden de las calles y las plazas, de las leyes *libros* y demas modos de vivir." Written in Barcelona, December, 1517.[7]

[29]

tion on the "books," but because soon after the Conquest, the misconception arose, and was expressed through four centuries, that Aztec paper was made from the fibers of the *maguey,* the century plant. This misconception so permeated the literature that it isolated the primitive American papercraft and took it out of its true perspective in the history of primitive paper everywhere.

But while Pietro Martire fingered the Aztec books trying to unravel the hieroglyphics, Hernán Cortés was trampling down with sufficient "blood and iron" the very civilization that produced these curious elements of culture. . . .

Paper ... from the Inner Bark of Trees

HERNÁN CORTÉS had found his glory.

Within three years after he had debarked from his ships in the "Rich Town" of Vera Cruz, he and his myrmidons had assaulted, conquered, and leveled the domain of the Aztecs. Having thus created his legend, Cortés settled down to govern the country that he had conquered while his restless knight errants set off, southward, for the conquest of the Maya.

The Cross soon followed the sword to the Aztec capital. Upon the arrival of the first Bishop of Mexico, Fray Juan de Zumárraga, in 1529, the spiritual assault on the conquered people began with the destruction of their learning. The agents of Zumárraga collected their hieroglyphic books from every quarter, especially from the "royal library" at Texcoco ("the most cultivated capital of Anahuac," says Prescott, "and the great repository of the national archives") and had them brought to the market place at Tlatelolco. There they were piled mountain-high. At a given moment, monks approached from all sides and set the torch to this gigantic pile of American learning. As the flames licked up the thousands of paper books, and the black smoke filled the Mexican sky, Zumárraga[1] could well take his place in iconoclastic history beside the Khalif Omar who destroyed most of the Alexandrian library. Well might Fray Juan de Zumárraga paraphrase the Khalif: "if the *tonalamatl* agree with the Bible, they are useless and superfluous; if they disagree – they are pernicious."

How complete was Zumárraga's destruction may be seen in the small number

of Aztec "books" extant. Of the thousands upon thousands of hieroglyphic charts, *tonalamatl,* genealogies, histories, and herbals only fourteen now survive.[2]

The destruction of the Aztec, physically and spiritually, was complete with the burning of the books at Tlatelolco but there still remained another center of learning — the Peninsula of Yucatan where the Maya still continued his ancient ways. To that land had gone the *conquistadores* and following them, as was their wont, were the soul-searching *padres.* And once more there was a fire in which books were burned.

In that year of infamy, 1561, Fray Diego de Landa was at the ancient town of Mani, the seat of the *Tutul Xiu* dynasty[3] watching the conflagration that was consuming the cornerstone of Maya civilization. Of this iconoclastic gesture, Diego de Landa writes:

"Among the Maya we found a great number of books written with their characters, and because they contained nothing but superstitions and falsehoods about the Devil, *we burned them all,* which the Indians felt most deeply and over which they showed much sorrow."[4]

On his arrival in 1549, Diego de Landa was assigned to the Monastery of Izamal,[5] where he began a study of the Maya language and made contact with the docile members of that tribe. A religious fanatic, an ardent missionary, he plunged into the depths of Maya life and legend with such zeal that in a few years he was Prior of the monastery. This he inaugurated by razing one of the most beautiful of Maya pyramids in order to obtain material to build his church. This destruction hardly influenced the Mayas in the benign aspects of Landa's God; in secret they still worshipped their ancient deities, still dropped small jade idols into their newly prepared *milpas* so as to insure fertility, still consulted their hidden books, this much to the chagrin of Landa, who had thought most of them already destroyed. He sought out and at last found the library in the town of Mani, seat of the *Tutul*

Xiu dynasty. There he discovered great archives* crammed with more "books." These his monks seized – piled up and destroyed. And he writes: *"We burned them."*[6]

Thus in the fires of Tlatelolco and Mani was destroyed almost the whole of the physical evidence of the paper of the Aztec and the Maya.

We have seen a glimpse of the importance paper played in the lives of the primitive Amerindian civilizations and it is an importance that cannot be overestimated. For after paper became general and was made into books upon which to record history and ritual, most of these civilizations became essentially predicated on its use. Now the question rises, how was the paper made and of what was it made? What would have once been simple to determine both as to technique and paper substance, now is complex since most of the books and paper rolls were destroyed, and the culture of the Indians decimated. What is more perplexing – the narratives of the chroniclers that followed the Conquest were less accurate than those who first narrated the assault on the civilizations of the New World. Again rhetorically, of what and how was American paper made?

First there was universal agreement among *conquistadores,* the proselytizing monks, and the chroniclers: Paper was made from a tree, from the bast fibers of the "inner bark" . . . *"Ex ficuum tabellis fiunt libelli"* . . . in the words of Pietro Martire. Then as time went on and the exploitation of the autochthons of America was the most absorbing fact and their lost culture, academic, an opinion was advanced that the paper of the Indians was made not from a tree at all, but from the rope-tough fibers of the *maguey,* the century plant; so a misconception was created that endured and still endures after four hundred years: this has a striking

* Bernal Diaz del Castillo also speaks of the book-repositories: "At Cempoalla (Vera Cruz) . . . in some temples we found instruments . . . much plumage of parrots . . . *and books of paper of the country* and folded in the manner of cloth of Castille . . ."[6]

parallel in the history of Asiatic papermaking. From Marco Polo's time until relatively recently, all Oriental paper was known as *Charta bombycina* – cotton paper. Linen rag-paper was assumed to have been an invention of a German or an Italian of the fifteenth century. The researches of Wiesner and Karabacek gave this theory a rude shock. Paper from the Great Chinese Wall proved, upon examination, to be of pure rag! And the date of papermaking was pushed far back to the second century! Furthermore, this discovery showed the paths of the old trade routes, the path of paper and the intellectual development of the Asiatic peoples.[7]

And so with the civilizations of America, and the role that paper played in its nurture. For it is important to understand the intellectual evolution of a people whose writing-medium began as tunics (in the form of bark-cloth), which then metamorphosed into long paper rolls for writing, and which as time went on evolved into books folded screenwise. Later, in its ultimate evolution, Aztec paper even developed into paper sheets.

Thus with the physical evidence destroyed and the literature filled with contradictions (and with these misconceptions stamped with the approval of authority by the most famed of Americanists) the problem is like some complex philological jig-saw puzzle: we must go back to the beginning again.

We have the learned Pietro Martire, "the most trustworthy of contemporary witnesses"[8] writing on the information that he had dug out from the men of Cortés – that the paper was made from the *inner bark of a tree* (for Cortés' men saw the paper being fashioned in Vera Cruz) and then from the notorious Bishop, Diego de Landa, a similar observation: "The paper on which they write their books, was made *from the roots of a tree.*" In examining some of the thousands of books that he burned, Diego de Landa explained:

"They wrote their books on a large and many-folded sheet, the whole of which they shut up within two nicely prepared boards. The writing was in columns and according itself to the folds. It covered both sides. *The paper was made from the*

roots of trees,* and was given a white luster on which they could write perfectly well."[9]

That, in sum, is all that Diego de Landa has to write about the books of the Maya, but the observation that American paper was made from the bark of trees is confirmed by at least five other contemporary witnesses,[10] and this constitutes almost the whole of the literary evidence of the chroniclers. It is important but it is scant. Moreover while it is obvious that they are in agreement about the paper having been made from the "bark of trees" apparently none, with the exception of Landa and that anonymous soldier informant of Pietro Martire, had ever seen paper being made; this is left to Francisco Hernández, the most important of our witnesses.

<div align="center">* * *</div>

Dr. Francisco Hernández was neither *conquistador,* priest, nor chronicler, but a scientist, the first naturalist to visit the Americas and one of the most brilliant of his time. Francisco Hernández came to Nueva España (as Mexico was now called) in 1570 as proto-medico to an expedition sent out by Philip II. What Hernández accomplished in the five years during which he travelled extensively in the highlands and lowlands of Mexico, and what were the fortunes of his great work on the animals, plants, diseases and remedies of the New World, is told in the Epilogue.** Here we need only occupy ourselves with his observations on the Aztec papercraft which he observed on one of his frequent visits to Tepoztlan:

"Many Indians," he writes, "are employed at this craft. The paper is not too well suited for writing or lining, although it does not blot the ink; it is more suited for

* The fig trees are buttressed with heavy swellings which, while part of the trunk, and not of the root, are called in Spanish *las raices del palo* (the roots of the stem). These, doubtless, were the roots referred to by Landa.

** Page 90.

bags and is very much used among these Indians for religious purposes, for making vestments (*amaquemitl*) and for funeral trappings."

Hernández continues with a detailed description of the processes of manufacture, the only accurate eye-witness account that exists in the literature. "To fashion the paper, they cut," he writes, "the larger branches from the tree . . . these are softened in water and allowed to soak all the night on the river banks. On the following day the outer bark is removed and cleaned of its outer crust with rock 'planches' shaped for the purpose, grooved with striations, and with a bunch of willow twigs passed through a hole and twisted for a handle. The bark is beaten out thoroughly with these stone beaters. It is thus rendered pliable. After this it is cut into strips which are easily joined together by beating the bark again with a smoother stone. They are then polished (by means of a *xicaltetl*)* and so finally fashioned into sheets of two dodrans (18 inches) long and one and one-half dodrans (13 ½ inches) wide. It is something like our own paper except that their paper is whiter and thicker, whilst ours is cheaper and heavier. However, it is not as good as our better quality of Castilian paper. I know that other distant nations make paper in other ways from the bark of trees also, but of them all, the Chinese make it thinner and finer, such as our own in Spain, which, while formerly made from rushes, is now made from flax."

The bark which Hernández saw being transformed into paper came, he tells us, from the *amaquahuitl,* which means literally paper-tree, since *ama(tl)* in the Nahuatl language is paper, and *quahuitl,* tree.

"The *amaquahuitl,*" Hernández continues, "is a large tree" with leaves like a fig tree and with white flowers and fruits arranged in clusters. It has almost no odor or taste and withal has a cool, dry nature. It thrives in the Tepoztlan mountains where frequently paper is made from it."

* "*Xicaltetl,* a certain varnish of white stone, upon which was painted or gilded; or a certain smooth stone which served for polishing." – Fray Alonzo de Molina."

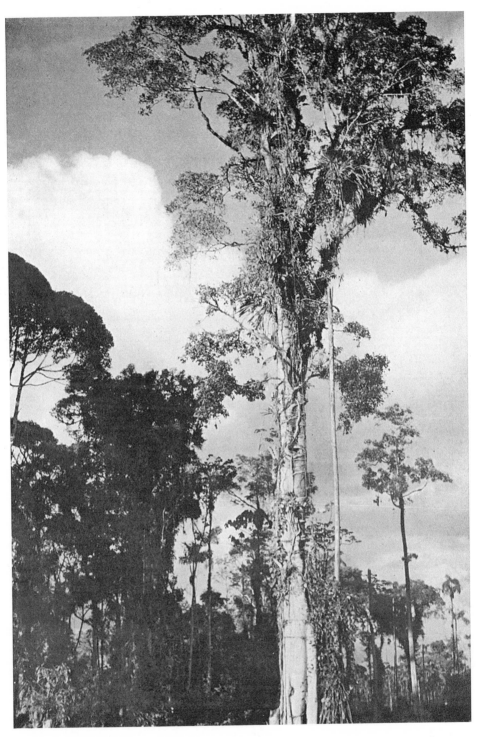

A South American strangler fig tree. From this species of Ficus, as well as from other closely related species, South American Indians beat their bark-cloths from the bast fibers of the inner bark.

He soon discovered, however, that it was not the only species of fig from which paper was made. He found that many species of wild fig were widely distributed in various regions of Mexico. These trees called *amatl* (hispanicized into *amate*) were found growing profusely in the *tierra fria* at an altitude as high as 2600 meters. This contradicts an impression left by another writer on Mexican paper who stated that the *amatl*-tree grows only in the *tierra caliente* and not at all in the Cordillera, "where the tree does not exist."[13]

The *amatl*-tree is easily recognizable by its corpulent trunk, ordinarily covered with a thin, smooth, pale, and often whitish bark, and by its broadly spreading crown. Hernández noted many species, particularly the *amacoztic* ('tree-of-the-yellow-paper') which the Indians he explains, "also call *texcalamatl* ('paper-tree-of-the-rocks') and still others *tepeamatl* ('paper-tree-that-grows-on-the-rocks'). The *amacoztic* is a large tree with broad leaves, almost round and thick and purplish like ivy and nearly heart-shaped. The bark is yellow and the inner bark somewhat red; it has fruits which resemble small figs and a trunk smooth like that of other fig trees."

Accompanying his description of the *amacoztic* his artist executed an excellent woodblock illustration of the leaves and fruit of the tree upon which Hernández bestowed the binomial classification of *Sycomor saxatilis* Mex 11. So well done is the illustration that an eminent authority on Mexican and Central American flora has identified Hernández' *amacoztic* as *Ficus petiolaris*,[14] one of the wild figs.

It has been common knowledge for more than a century that all the trees known to the Aztecs as *amatl* and the Spanish as *amate* belong to the genus *Ficus*, a tropicopolitan group of trees with a wide distribution in both western and eastern hemispheres.[15] In Mexico there are more than fifty species of wild fig spread throughout all parts of the country. The best-known species of *Ficus* is the cultivated fig (*F. carica*) and the rubber plant (*F. elastica*). The *Ficus* is a Moraceae, one of the mulberry family which not only provided the fibers for early Asiatic paper, but

from it *tapa* is beaten in Polynesia and Micronesia, as well as in Africa and Celebes. The fig tree and its allied species thus provide comparative ethnology with a pertinent example of parallel cultural evolution everywhere among primitive peoples.

Early in Aztec history, the word for the tree *amatl* became synonymous with the paper made from it. Among other tribes the association was similar. In the Tarascan language the word for both fig tree and paper was *siranda;* among the Maya and the Chorti, the word for paper was *huun,* and among another Guatemalan people, the Kekchi, it was called *hu.*

The researches of Hernández were greatly facilitated by the highly developed botanical system of the Aztecs, comparable to modern nomenclature which had its beginnings with Linnaeus in the eighteenth century; in many instances, the Aztec system is actually superior in descriptive scope.*

In the Aztec botanical system "there were two great natural Orders, the woody plants which carried the term *quauh* and the herbaceous, with the term *xiuh*. All of these were further divided into four great classes based on use: edible, medicinal, ornamental and economic plants. Families were formed based on the special characteristic quality of some type-members, just as with us." *Amaquahuitl,* the paper-tree, was, for example, the type-specimen, every variety having the term *ama* or *amat* as prefix or suffix. "Within these families were then ranged the different Genera, just as with us, the type-genus being one." Species were defined "by a true binomial nomenclature paralleling our own" with the addition of a third, fourth and even fifth term building up compound word formations in which the Aztec was exceedingly rich and flexible. Thus, *aca-capac-quilitl* means "pleasing-cane-edible" and *tzonpilihuiz-xihuitl* is "cold-in-the-head or catarrh-plant."

* I am fully indebted to the late William Gates for this "Introduction to the Mexican Botanical System" as outlined in the following pages. The whole of it is taken from the *De La Cruz – Badiano Aztec Herbal* (1939) either in direct quotation or occasional paraphrase for the purpose of bringing the examples pertinent to paper writing to the fore.

"For the development of this great system of classification and nomenclature, every part of the plant, together with its various relations and likenesses, was studied and made use of. . . . This involved description by color, size, shape, surface appearance; as being sweet, acidulous, bitter, burning, salty; as feeling rough, smooth, rigid, hairy, furry; as smelling this or that. . . . The habitat might be in cold regions or hot; in field, forest or garden; on stony soil, crags or walls; in marshes, water . . . water-side . . . also geographical districts, by name." Root, stalk, leaves and seasonal character were noted and sometimes used in definition. Economic use we have already seen indicated in "paper-tree." Other examples of this nomenclature applied to species of *Ficus* are *amacoztic* ('yellow fig'), *hoeiamatl* ('great fig tree'), *tepeamatl* ('fig-tree-that-grows-on-rocks.') "Finally the immense artificial class of Medicinal Plants would yield innumerable descriptive terms of primary value." In this respect, as Gates points out, the Aztec taxonomy was far ahead of that used today: ". . . scientific and practical, and clear; definite and also expansible to any degree, as much as ours. . . . Their science grew up and developed while they had painting and pictographic writing as their aids only. . . . Their writing signs did not give the sounds of the words, but only the picture or idea of the thing."

"This pictography was of two kinds, symbolic and natural. . . . The type-characteristic of the Family or other division was a condensed symbol, eliminating at times everything but the essential, as the conoid inflorescence of the pine, the red 'berries' of the tomato, etc. Color aided: tree-stalks would be brown, leaves green. . . . The line between the artificial and natural, the symbolic and the pictorial followed over into this written memorial, to give a didactic-mnemonic science, using symbolic signs applied to plant groups, and various figurative determinants to denote the species. All this was then matched by the . . . synthetic incorporate words."

In view of all this, the pictographic symbols become of the utmost importance

in the search for the origins of primitive American paper, the symbols, for instance, that give us the root *ama* in the paper, the tree from which it was made, the book it was made into (*tonalamatl,* book containing the sacred almanac), and often the village that was the tree's habitat. Thus we have Amatepec ('Mountain of the fig trees'), Amacoztitlan ('Place of the yellow fig tree'), Amaquemecan ('Place where they dress in clothes made from the fig tree'), etc.*

In Molina's Spanish-Aztec Dictionary, compiled soon after the Conquest, we find the word for paper given as *iztacamatl.* But *iztacamatl* is only one type of paper, that made from the white fig trees in the village of Iztacamatitlan. Paper was made from the bark of many species of the fig, depending on those to be found in a given papermaking region. Francisco Hernández, in addition to the type tree, *amaquahuitl,* gives a number of fig trees from which paper was made.**

So we are now no longer in the clouds, but close to the earth. Hernández[16] had

* Amacoatitlan	Between the serpents of the fig trees
Amacuzoc	River of the yellow fig trees
Amatitlan	Place of the fig trees
Amatlan	Near to the fig trees
Amayuca	Where paper is made
And so on, ad infinitum.	

** *Amaquahuitl seu arbore papyri* ... paper-tree
Amacoztic seu papyro lutea . . . yellow paper
Tlacoamatl seu virga papyracea . . . papyrus stalk.
"It is called *tlacoamatl* because of its similarity to the *amaquahuitl* in size, shape, leaves, odor, and strength of bark and wood. . . . It thrives in tropical and frigid climates and is also found in temperate areas, such as Mexico" [Tenochtitlan. This is undoubtedly *Ficus padifolia*].

Amatzauhtli seu glutine papyraceo . . . papyrus glue. "Has roots like fibers and small

seen the papercraft in process, had identified and drawn the trees. His findings and our understanding of the pictographic botanic symbols and of their translated meanings—all tell us that the Aztecs and Mayas made paper from *"the inner bark of trees,"* and furthermore that these were fig trees.

metl leaves tending in color toward the scarlet. It thrives in mountainous and rocky regions such as Tepoztlan, where we had a drawing of it." [An orchid, *Epidendrum Pastoris* – the secretions were used for glue.]

Ytzamatl seu papyro novaculari . . . dagger papyrus. "It is a tree of vast proportions and similar to *amaquahuitl* from which paper is made, but its leaves have the shape of daggers. . . . There are two species, one with large leaves like those of *Malus Medica* with sparse foliage at the bottom, dense at the top. The wood of both is tough and short-grained."

Hoeiamatl seu Amatl magna . . . great fig tree. "It is a large tree with large leaves like those of *Malus Medica* ('medicinal apple') and a rather whitish trunk. . . . It grows in Huaxtepec and other warm places. . . ." [Perhaps *F. padifolia*, the *amate blanco* of modern Mexico.]

A Good Paper Is Made from Metl

It was Fray Toribio Benavente, known as Motolinía (the poor one), who first beclouded the issue.[1] He was one of the Franciscans sent to New Spain to assist in the spiritual education of the Aztecs; and, being a monk of parts, he turned historian. "A good paper," he writes, "is made from *metl* [Agave]: the sheet is as large as two sheets of ours, and they make much of this in Tlaxcala and throughout a great part of New Spain. There are other trees from which it is made in the hot-lands, and of these they are accustomed to use a great quantity. *The tree and the paper is called amatl* and from this they call letters and books and paper *amate,* although there is also a special name for books [*tonalamatl*]."

Now *metl,* which is synonymous with the *maguey, pita,* or aloe is botanically an *Agave** (known in North America as the century plant) a genus of a large and important amaryllidaceous family of plants with large-spined, fleshy-leaved pads which furnished the peoples of Mexico with drink, food, spines, gutters for thatching, fibers for shoes and clothing. Its importance to native economy was unmatched by that of any other plant, but not one of the chroniclers ever saw paper being made from it. Still, López de Gómara, Cortés' secretary,[2] confirms the statement of Motolinía with: "their paper is made from *metl,* which is used at their sacrifices and by their painters." Francisco Hernández[3] examined most of

* *Agave* – illustrious, noble. *Agave,* the mother of Pentheus. Name given to these plants by Linnaeus because of their noble bearing and importance in Aztec economy.

the *maguey* family and he, too, detailing the uses to which it was put, says, *"papyri filique,"** – but there it ends; there is no further explanation. From that time on, throughout the colonial period and up to the present day, "a good paper is made from *metl*" was repeated over and over, the description of its fabrication being taken not from actuality, but from the exact description given by Hernández of the manufacture of paper from the fibers of the *amatl*-fig-tree.

In 1764 the Chevalier Lorenzo Boturini writes:

"Indian paper was made from the leaves of the *maguey* which in the language of the natives, was called *metl* and in Spanish, pita. The leaves are soaked, putrefied, and the fibers washed, smoothed, and extended for the manufacture of thin, as well as thick, paper. After polishing them they painted upon them. They also know how to make paper from palm leaves, and I have in my possession a few samples of this sort, which are smooth as silk."[4]

We may be permitted to doubt if the good Chevalier, in his peregrinations about the Mexican countryside between the years 1735 and 1740, had ever seen the natives putrefy and smooth out the fibers of the *maguey,* if for no other reason than that, coarse, woody, and covered with a thick pulp, they are incapable of extension by beating, as are, for example, the inextricably interlaced fibers of the mulberry. The coarseness and woodiness of the *maguey* fibers constitute their strength, and when cut green from the casing of a succulent pad, they are fashioned into strong cordage. Such are the rope, the sandals, the bags, made from henequen. Actually, if one has the technical equipment, paper can be made from anything fibrous: asparagus butts, cabbage leaves, wasp nests, and even succulents; but the process includes felting the fibers (after they have been soaked, and beaten by mechani-

* The *amatl*-paper offering tipped with rubber was called *amateteuitl* and the presence of the prefix *amat* should readily have explained that the origin of the paper was from the *amatl*-tree.

cal means to minute particles) on a papermaking mould invented by the Chinese. And this mould was unknown to the Aztecs; in fact, it has never been found among those whom we call "primitive people."

The Chevalier, however, firmly believed he had seen what he later reported. He was inclined to the marvelous, and it was actually his addiction to the supernatural that led to his interest in the natural. He had visited the shrine of the celebrated Lady of Guadalupe, and being of a devout and enthusiastic temper, he became filled with the desire to establish the fact of the Lady's apparition. In the course of his quixotic search for the evidence, he covered much Mexican ground and made an extensive collection of Aztec codices, the largest then known. If we dwell on the Chevalier, it is not to deprecate his efforts or his knowledge; it is because, by stating that "a good paper is made from *metl*," he continued a trend begun by Motolinía (in the wrong direction). The fact that paper was made from a *tree*, and not from the *maguey*, was lost in the limbo of history.

Notwithstanding the enormous number of paintings burned by the missionaries, Boturini succeeded in collecting nearly five hundred native hieroglyphic books, which he said were "the only property he possessed in the Indies that he would not exchange for all the gold and silver in the New World."

Nevertheless, his collecting zeal ended disastrously for him, for, intent upon having Rome authorize "a coronation of the sacred image at Guadalupe," he jumped the gun, so to speak, and proceeded before sanction was actually given by the Council of the Indies. This caused Boturini, a Milanese by birth, grave difficulty with that august body. He was summarily imprisoned and deported to Spain. During his confinement he composed his *Idea of a General History* without recourse to any of his notes and documents, for they lay mouldering, along with all the Aztec codices, in his house in Mexico City, where they were found by Humboldt in 1804. The vicissitudes of poor Boturini interest us only insofar as they cast dubious light on his observations. His work on Aztec antiquities is pronounced by

Prescott to be "ill assorted and ill digested—a jumble of fact and puerile fiction, interesting details, crazy dreams, and fantastic theories."[5] Whether or not so pungent a criticism is justified, it gives the background of the theme: "Indian paper was made from the leaves of the *maguey*," developed by Boturini from the merest mention by the chroniclers and taken up after him by the Mexican historian Francisco Clavigero, who wrote (about 1785):[6] "The cloth* on which they painted was made of the thread of the *maguey* or aloe or the palm icxotl.** . . . They made paper of the leaves of certain species of aloe steeped together like hemp, and afterward washed and stretched and smoothed. . . ." This potpourri was disdained by Lorenzana, the Archbishop of Mexico, who, somewhat later, preferred to plagiarize Boturini's description in his *Idea de una Nueva Historia.*

"Paper," Lorenzana wrote, "was made from the leaves of the *maguey*, which in Spanish is called *pita.* The leaves of this plant were first soaked in water in order to putrefy them. Then they washed the fibers, smoothed them and extended them for the manufacture of their coarse paper, which was then polished in order to paint on it. They also had a fine sort of paper, made of palms and white like silk, which I have seen; the leaves of the palm were gathered, ground, beaten, and then polished."[7]

The texts of Lorenzana and Boturini are almost identical, and both seek to cre-

* By cloth he probably meant the cotton textile on which the Aztecs sometimes painted, known as *lienzo* (linen). (See plate I for illustration of a *lienzo*.)

** "*Icxotl*" [izotl] is often referred to as yielding a "paper as fine as silk." *Icxotl* belongs to the Yucca species, in appearance much like the Joshua Tree (*Yucca arborescens*) of the United States. A delicate "paper" might have been made of the thin, lance-shaped leaves by laminating them, a method used by the Egyptians in making papyrus; but it is doubtful. The etymological proof which Nicolas Leon gives as adducing that this plant was used for papermaking is very poor. His "*zoyamatl*" (papel de palma) and *texamatl* (papel de pena) are only native terms for the fig tree *Ficus petiolaris.*

ate the impression that the writers have actually seen the manufacture of paper. But native crafts and industries had been buried for more than a century by acts of economic exclusivism by which Spain alone became the manufacturer and her colonies merely producers of raw material. There were exceptions, however; machinery for modern papermaking, mechanisms for reducing pulp and forming sheets on moulds such as were then being used in Europe, were brought to Mexico as early as 1580,[8] and so Aztec paper, by native processes, was made for ceremonial purposes only, in the secret recesses of regions hidden from the eyes of archbishops. In the eighteenth century, paper imported from Spain and paper made with machinery in Mexico were clearly differentiated from native *amatl*-paper.*

By the time Alexander von Humboldt arrived in Mexico, where he discovered Boturini's Aztec codices in the capital, the belief, "a good paper is made from *metl*," had permeated places high and low; and so this scientific discoverer of America was led to the same conclusion. The Aztec codices he brought back to Europe were marked for more than a century with a notation in his own hand: *"Aus Agavefasern gemacht."*

The eminent scientist and traveler, who had seen the meeting of the Orinoco with the Río Negro, who had climbed Chimborazo and viewed the civilization of the Incas, instantly pounced on the opportunity of acquiring some of Boturini's codices. In the winter of 1804 they were put up at auction by a Señor Gam. "These valuable relics," Humboldt wrote at the time, "were preserved with so little care,

* When Boturini was arraigned before the Royal Magistrates in Mexico for his assumption of powers in relation to the miracles of Our Lady of Guadalupe, his numerous papers and collections of native documents were detailed before the examining magistrate. The notary was careful to distinguish between native and European papers. These were some of the terms in that document: *papel de maguey; papel indiana; papel de castilla; papel de maquilla; papel de marca;* etc. Generally, native paper was differentiated from *papel de castilla* (paper from Castile) as *papel de maguey.*

that there exists at present only an eighth part of the hieroglyphic manuscripts taken from the Italian traveler."[9]

Part of the collection had accompanied Boturini when he had sailed for Spain, a prisoner. On the high seas his vessel fell in with an English privateer; it is not known whether his treasures were taken to England or dumped into the ocean. What remained in Mexico City was confiscated, "torn, pillaged and dispersed by persons ignorant of the value of these objects."[10] What existed at the time of Humboldt's visit, lay in the Palace of the Viceroy and was composed of only "three packets, seven decimeters square by five in height. They remained in one of the damp apartments on the ground floor, with the archives of the government which the Viceroy, Count Revillagigedo, later removed because the humidity mouldered the paper with alarming rapidity.[11] Humboldt was unable to examine them all, but one Aztec codex he describes as six meters long and two broad, representing in pictographs "the migrations of the Aztecs from the Río Gila to the Valley of Tenochtitlan." Those codices which he was able to purchase were sent to Berlin and form the basis of the American collections there; all were marked *"Aus Agavefasern gemacht."*

Humboldt did not see the native process of papermaking in Mexico; had he seen it, so excellent an observer as he would have recorded it more exactly. "The paper," he wrote, "which was used for the hieroglyphical paintings of the Aztec people, has a great resemblance to the Egyptian paper. . . . The plant which was employed in Mexico for the fabrication of paper is known to our gardens under the name of aloe. It is the *pita (Agave americana),* called *metl* or *maguey* by the people of the Aztec race. The mode of making this paper was very similar to that employed in the South Sea Islands with the bark of the mulberry *(broussonetia papyrifera).* I have seen pieces three meters long by two broad. The agave is cultivated not for papermaking, but for preparing with its juice the intoxicating liquor called *octli.*"[12]

[47]

Although Humboldt repeated the statements of Boturini and Lorenzana that paper was fabricated from the *maguey,* he added a new observation of great importance: "The mode of making this paper was very similar to that employed in the South Sea Islands *with the bark of the mulberry.*" So it becomes doubly certain that this great traveler, the first modern scientist to come to the Americas, did not see the *amatl*-papercraft, for the method he refers to could not have been applied to the fibers of the *maguey.* His comparison between the people of the South Sea Islands and those of Mexico is most acute. Had he actually seen the paper being made, he would have recognized at once that the methods of the Aztecs and the South Sea Islanders were not only "very similar," but *identical;* he would also have seen that the fibers used were not those of the *maguey.*

Alexander von Humboldt, who had left his impress on so many fields of knowledge, left it also on the problem of the Aztec paper; he took the theme, "good paper is made from *metl,*" and, by repeating it and enlarging on it, gave it authority for another century. Prescott followed suit, writing that "Their manuscripts were made of different materials, cotton cloths, or skins, nicely prepared; of a composition of silk and gum; but for the most part of a fine fabric from the leaves of the aloe, *Agave americana,* called by the natives, *maguey.* . . . A sort of paper was made from it resembling somewhat the Egyptian papyrus which, when properly dressed and polished, is said to have been more soft and beautiful than parchment." [13]

After Prescott, the Mexican scholar, García Icazbalceta, stated that the paper was made of cotton, [14] and Lucien Biart, [15] in a highly imaginative account of paper-sources, confused the question still further. "Paper was obtained from various substances, but the most appreciated was made from *Agave* leaves which were soaked for a long time and afterward washed in a large quantity of water and then polished. Paper was also made – but of an inferior quality – from palm leaves, fine

bark coated with gum and, lastly, from cotton. That called *cuauhamacatl* (wood paper) came from the *amacahuite* tree of the borage family."

Would anyone recognize in all this, the simple direct statements of the chroniclers who accompanied the *conquistadores* that the natives had books, and that the paper of these books was made "from the inner bark of trees?"

Yet, now our scholars identify the paper of the Aztecs as from that of leaves of the *maguey,* cotton, palm leaves, fine bark coated with gum, a confusion sufficiently echoed by the authorities of today.[16] Little more can be learned from the literature for we have become the men that Rémy de Gourmont speaks about who "unravel everything in theory and tangle up everything in fact."

The writer then believed that if an answer was to be found, it must come from original sources. There were no end of clues. But the scene must change radically for its unearthing. . . .

There is a trail that leads far from the shores of Vera Cruz where Cortés enacted the drama that gave us the first glimpse of primitive American paper, it is even beyond the domain of the Maya. South of Mayadom in the republics of Honduras and Nicaragua, on the banks of a verdure-sealed river, a primitive people, renouncing modern ways, move about in short bark-cloth tunics.

We have left the world of books.

The Paper Clue of the Sumus

I⊤ was night in Honduras. A fire burned fiercely in the center of a primitive palm-plaited dwelling on the upper Río Patuca. The dancing shadows thrown up by the fire played upon the split balsa uprights and the blackened palm thatch. An old Indian bent over a piece of white bark-cloth muttering incantations while, with faltering hand, he painted in lurid colors the symbols that he alone of the shamans of the Sumus knew. He was the last of the Oldmen of the Patuca Sumus of Honduras, the last to keep to the ancient traditions that time and white man's usurpation had jettisoned.

Standing to one side, watching the Sumu witch-doctor marking his bark-paper with concentric circles and lines, I felt less interest in this primitive necromancy than in the substance on which he was scribbling; in the morning I had learned that their bark-paper was called *amat* and that it was becoming "very scarce."

Was *amat* the same as the *amatl* of the Aztecs? Was this not a clue to the origins of papermaking among the Maya and Aztec? The next day brought the answer. I went to the jungle with a Sumu Indian, watched him select a branch from a tall wild fig tree,* cut it, and from then on the process of splitting the bark and peeling it from the branch was identical with the process that Francisco Hernández had observed in the Mexican village of Tepoztlan in 1571. What I saw became the key to the fabrication of the *huun*-paper of the Mayas and the *amatl*-paper of

* Collected by the writer and identified by Dr. Paul Standley as *Ficus padifolia*, one of the trees used by the papermakers of Mexico.

the Aztecs. I saw, too, why the books of *amatl*-paper were folded like a screen. First the branch of the wild fig, ten inches in diameter and twenty feet in length, was split down the center and the bark peeled off in a single sheet. This gave a strip thirty inches wide by twenty feet long. Tied in a bundle and weighted down with a large rock, the bark was left to soak in the river for several days to draw out its milk, or sap (for the *Ficus* trees are known for the abundance of milky-white sap which exudes the moment that either trunk, branch, or leaves are lacerated). After this soaking the bark was taken out, and the sap, which had coagulated into thick, gummy masses, was scraped off. The bark dried in the sun, which causes a certain amount of shrinkage. It is then taken indoors and wetted again before beating. The extension of the bark is accomplished by laying it over a small, smooth log and vigorously pounding it with a wooden mallet. This phase of the operation is called *lanlan* by the Sumus; the mallet is a *para*. Its shape, as will be seen in the illustration, is that of a thick, short club, into which parallel, longitudinal ridges have been cut. Under the heavy pounding of the ridged beater the tightly interlaced fibers of the wild fig begin to separate and grow thinner. As they are pounded into a homogeneous mass, with a pattern of strokes this way and that, they gradually assume a smooth surface, as though they had actually been felted in a mould. After several hours of this treatment the whole piece of bark is transformed into a soft, pliable, and relatively thin piece of "bark-paper."* This state is called *amat* by the Sumus.[1] And in this technique the Indians have much in common with other cultures elsewhere.

Primitive paper or bark-cloth, wherever it is found, whether on the African coast, or in Java, the Fiji Islands or the Tonga Islands, Sumatra, the Celebes, or Hawaii, is always made from the mulberry or its close relative, the fig.[2] The

* The *Ficus* is called *tikan* and the finished bark-paper *amat*; there is another form of bark-paper, whiter than *amat*, which the Sumus call *yakuta*. The Miskitos, coastal neighbors of the Sumus, call it *tunu*. (See plate 11).

processes are everywhere almost identical, as far as they go. Only the most advanced papermakers of the Aztec and Maya civilizations, when they beat the fibers into paper sheets, carried primitive papermaking close to the true paper of the Chinese. Even the bark-beaters of Mexico, Polynesia, and of the Tlingits of Alaska are similar, almost the same in construction and shape, though they may be made of different materials and have slight differences of detail or proportion. They may be stone mallets, wooden clubs, grooved and ribbed horizontally or vertically, or even flat pieces of basalt. A type of beater found in Mexico has been described as "of a fine-grained, rather heavy green stone"; it is a pounding club or mallet with a handle and beating body in one piece; it measures seven and one-fourth inches in length. The handle presents an elliptical cross-section, while the beating body is almost rectangular in such a section; the four almost flat faces measure a little less than two inches across, three are smooth, while the fourth is ribbed with ten longitudinal ridges produced by nine grooves. . . . The Polynesian and Tlingit specimens are longer and more slender than the Mexican, but all three are plainly one implement.[3] All present a form of club with handle and beating body in one piece; all show a rectangular section of the beating portion; all present three smooth faces and one grooved and ribbed.

Moreover, if the technique of primitive papermaking or bark-cloth fashioning is similar, even down to the plant used, then also are the uses to which it is put. For not only do the Sumus use the same *"inner bark of the tree"* as the papermakers of Tepoztlan observed by Hernández in 1571[4] and follow exactly the same methods and practices, they also illustrate the evolution of the bark-cloth from clothing to writing material. Once *amat* among the Sumu was used exclusively for their poncho-tunics.[5] Then they used it to draw on and in the performance of magic rituals, all stepping stones in the process of cultural evolution. The Jicaques of Honduras, their neighbors, still fashion their tunics from beaten wild fig bark.[6] The Lacandones of El Peten, in Guatemala, still use poncho-tunics of beaten

bark-cloth made from precisely the same tree that yielded the *huun*-paper of the Mayas. Even among the ancient Mayas the priests wore tunics of bark-cloth, sometimes undecorated, sometimes painted with cabalistic signs and magic symbols in bright colors.*

In Mexico too, in ancient times, the *amatl*-tree furnished clothing for high and low. Even when the Aztecs were at the height of their power and fine textiles were in common use, the greatest nobles, when ushered into the presence of their chief, were forced to appear in bark-cloth, as a gesture of humility. Bark-cloth tunics also occurred among the Maoris, who had first worn garments fashioned of *tapa* (the beaten bark of the mulberry—*Broussonetia papyrifera*), long strips that passed between the legs and around the waist; the women wore kilts of the same. But when they migrated to New Zealand, bringing their mulberry plants with them, they found that the mulberry did not grow well. Even though they evolved a cloth from flax fibers, a sentimental tradition which in time became ritual, kept them attached to their traditional *tapa* bark-cloth clothing.[7]** On great occasions bark-cloth was used and the small amount obtainable became adornment for the gods. In the Americas it is obvious from the far-flung distribution of bark beaters in the Middle Cultures of Mexico, that the pounding of bark was very ancient. As everywhere else, it was first made into clothing—names of towns such as Amecameca (Place-where-they-have-shirts-of-*amatl*-bark) are deeply suggestive—and clothing continued to be made of it even at the time of the Aztecs,

* This is equally true of the Indians of South America, where bark-cloth from the wild fig is beaten by various tribes. In many, both tree and prepared bark-cloth have the same name. The Yungas of Peru call both *llanchama*. This has been identified by MacBride (*Flora of Peru* Part II, no. 2 1937) as *Ficus radula* Willd. The list could be extended indefinitely.

** This holds true also among the Bushongs of Africa. Material for clothing introduced among them over three hundred years ago is still regarded as an innovation. For ceremonial purposes the tribal dignitaries use bark-cloth, as that was the clothing of their ancestors.[8]

although by then it was also being used for paper;* paper covered first, with pictographs, then with more and more complex hieroglyphs. Then the large sheets of *amatl*-paper were made into books, folded screenwise because of their length, and eventually "bound" with boards often ornamented with turquoise and jade. The Sumus provided the real basic clue; we had cut through the maze of contradictions back to the very core of the problem. In one vast panorama we could see the entire evolution of American paper from bark-cloth tunics to folded books. Still more important, the technique of the Sumus agreed in every detail with that seen by Francisco Hernández even to the very tree. Yet this was Central America, a thousand miles from the papermaking regions of Mexico. Perhaps it would be different in Mexico. Why not Mexico then? Was it not reported as late as 1924 that the Otomi Indians in the State of Puebla⁹ still made paper (in secret) as did their ancestors?

The puzzle is beginning to take form.

* Among the Egyptians paper had a similar evolution. In Egypt papyrus was first used to construct boats, then as roofing for buildings, then as headgear and finally as paper. The Chinese, who invented paper, first wrote on silk. Then they advanced to the point of taking silk-residue, disintegrating the fibers, and packing them in a mould. In the modern world the step from clothes to paper is no less apparent, for it was not until Europeans began to wear linen undergarments that there was a rag-source for the manufacture of paper.

The Otomi Papermakers

In the village courtroom of the little town of San Pablito, an Otomi Indian woman had been brought before the judge and accused of witchcraft. To prove his case her accuser brought forward a large paper doll, a *muñeco* made from *amatl*-paper. Its body was punctured with spines which, he claimed, would cause pain in the body of the human victim when the sorceress uttered the appropriate incantation. Whether the Indian woman was found guilty or not, her trial, itself only a minor incident in the still-very-much-alive arena of witchcraft, had an interesting denouement: Dr. Frederick Starr,[1] ethnologist, visiting Mexico in 1899, heard of it, and Xochihua, his educated and intelligent Indian, informed him that the Otomi Indians still made paper, as did their ancestors from the trees that filled the *quebradas* of Puebla.

Starr investigated Otomi papermaking, but he was no botanist, and his guesses as to the specific botanical source of Otomi paper were wide of the mark. However, his recorded observations brought to the papermaking village in succession, Dard Hunter, Dr. Nicolas Leon,[2] of the Museo Nacional de Mexico, and later, in 1931, the present writer, in search of the paper-horizons of ancient Mexico, all of whom looked upon the continuance of papermaking merely as an ethnological curiosity. When, however, proof that the *Ficus* species was the plant involved in ancient papermaking began to multiply, the writer was fortunate enough to make contact

with two residents of Mexico, Señor Hans Lenz,* who was interested in paper generally and Miss Bodil Christensen,** whose interests were ethnological. With their aid still more evidence was pyramided toward the solution of the problem of the botanical substances involved in the manufacture of primitive American paper.

The art of papermaking "from the inner bark of trees" still survives in secrecy and isolation in the Otomi villages of the states of Puebla and Hidalgo, and among the Chicóntepec-Aztec Indians in the warmer regions of the *tierra templada* of Vera Cruz.*** The papermaking Otomis live in the Sierra, 1,000 meters above sea level, where Puebla, Hidalgo, and Vera Cruz come together. There, as Starr pointed out, several tribes – Aztecs, Otomis, Tepehuas, and Totonacs – are "sandwiched together in the strangest way." One village may be Totonac, the next Aztec, Tepehua or Otomi. It is the Otomis, however, who are the papermakers; the manufacture of paper centers about the little grass-thatched village of San Pablito, Puebla.

There are no great haciendas among these people. Most of the land is owned

* Señor Hans Lenz, author of the excellent monograph on colonial and modern paper-making in Mexico,[3] kindly supplied me with notes on the Otomis, as well as with photographs and the samples of their paper which appear in this volume.

** Bodil Christensen, who recently published a study of witchcraft among the Otomis,[4] assisted in collecting botanical specimens and taking photographs. She also conducted for me an expedition into Vera Cruz to study primitive papermaking and gather the paper samples that form part of this volume. Her assistance was invaluable.

*** The papermaking villages are:
Puebla: San Pablito, Sierra de Puebla, Distrito de Pahuatlán;
Ixtoloya, Distrito de Pantepec.
Hidalgo: San Gregorio, Distrito de Tenango;
Xalapa, Distrito de Zacualtipan.
Vera Cruz: Ixhuatlan, Municipalidad de Chicóntepec.

by the Indians themselves, and is cultivated with the usual subsistence crops of Mexico: corn, frijoles, cacahuates, garbanzos and chili. In these valleys the most conspicuous tree is the wild fig, growing along the banks of streams and in sections where water is immediately below the surface. The moisture-loving *Ficus* and its allies are the plants used by the Otomis. At night or during those parts of the day when there is little else to do the Otomis become papermakers.

Like the natives of ancient Tepoztlan whose papermaking was described by Hernández, the Otomis of today pull off five-foot long strips from the paperplants. The outer bark is then removed by peeling, the freshly peeled bark allowed to soak in running water, so that the abundant latex may coagulate and be scraped off. Then – and here the women take over – the fibers are dried and then boiled in a large kettle filled with *nixtamal,* the lime-water residue in which kernels of maize have been soaked. After hours of boiling, the softened bast-fibers are taken from the lime-water, washed again in cold water and placed in a large gourd.

To fashion paper, only two instruments are necessary: a flat, smooth, wooden surface like a bread-board, and a striated stone called a *muinto* (from Otomi *muini,* to hit). It is to be noted that this beating-stone is identical with the so-called *planches,* the archaeological artifacts which are found throughout all Mexico. In fact the Otomis prefer to use an ancient stone if they can find one. Pieces of boiled fiber are now taken, cut to conform to the shape of the board and pounded with a *muinto* until the strips are felted together to form a continuous surface. Then, the paper, still sticking to the board, is sun-dried. When finished, it presents a smooth surface on the side which faced the board, and a roughened surface over which the *muinto* was rubbed. In this state the paper, four by nine inches, is known to the Otomis as *tze-cuá.* It is put together in quarterfolds, bound six to a package, and offered for sale in their little market on Dia de Plaza.

The Otomis seem no longer to know for what purpose paper once served. For

them it is magical, its use only for witchcraft and the ritual-soaked ceremonies of the annual feast *La Costumbre* (the custom). This revolves around the belief that the spirit of Montezuma which gives health and fertile fields to his people will some day return. That his spirit may partake of the feast, a table is taken to an isolated spot and on it are placed *muñecos* (paper dolls) and other ceremonial symbols cut from the *amatl*-paper made by the Otomis. To show some of the ramifications of witchcraft, Starr* cites the case of the judge at San Pablito, before whom was brought the woman who had made an *amatl*-paper *muñeco* into the symbol portrait of one whom she would injure. But someone else, it seems, had made a *muñeco* of the judge which had its mouth sewn together with thread, so that he would be unable to pronounce sentence. Such is the lamentable decadence of Mexican paper.

Four species of Moraceae are involved in the manufacture of Otomi paper. In the identification of these plants there can be no mistake. The leaves, the fruits, and the bark were gathered by Miss Christensen under my direction and were identified by Dr. Paul Standley of the Field Museum. It is a remarkable confirmation. For not only is the paper technique the same as that of the ancient Aztecs, but the plants, too, confirm the words of Hernández, that Mexican paper is "made from a tree, a large tree with leaves like a fig and with white flowers and fruits arranged in clusters... which is called the *amaquahuitl*."

Among the Otomis the tree most in use has the local name *Xalamatl limon* (Otomi, *muxi-coni*) and this has been identified as *Ficus padifolia*. The *Xalamatl* (Otomi, *popa-tza*), which yields a russet-colored paper, has been identified as *Ficus Goldmanii*. Another paper-plant is the nettle-bush *tzitzicaztli* (*Urera baccifera*), also belonging to the Moraceae. And of great interest is the fourth paper-

* "Según un fragmento de la 'Historia de México' atribuido al Padre Fray Andrés de Olmos, la invención y uso del papel entre las tribus de México dataría de los tiempos más antiguos de que hay noticia, pues allí se lee que los Otomies, desde remotísimas, vestían a sus idolos con papel de maguey."

plant, the mulberry (Spanish, *Moral;** Otomi, *Tza-tze-cuá*), which has been identified as *Morus celtifolia,* a paper-mulberry similar to the plant used by many Asiatic papermakers.

So the Otomis, though they have forgotten the varied uses to which their ancestors put the *amatl*-paper, still employ the most advanced techniques developed by pre-Columbian Aztec craftsmen, of the village of Amacoztitlan, who also disintegrated the *amatl* fibers in boiling lime-water and felted the paper to form sheets. Of these they were tribute 160,000 sheets annually to Montezuma II.

And the Otomis are not the only papermakers in Mexico. Some miles distant, close to the border of Hidalgo, is the Aztec village of Chicóntepec in the State of Vera Cruz. At an altitude of 600 meters, where the sierra ends the Huaxteca begins, the landscape sweeps down in big slopes and isolated hills stand in relief. These are the chicome-tepetl – the Seven Hills – and from them Chicóntepec derives its name. Here the Nahuatl-speaking people, still living in ancient ways, still immersed in their milpa culture, like the Otomis, are in their leisure moments, papermakers. They gather the bark of the trees when the moon is new (*cuando está tierna la luna*) and proceed to soak, boil, and pound in the Otomi manner. But instead of a stone, these Indians use a fire-hardened corn cob. Their paper, which they call *cuah-amatl*, is tougher, thicker, and finer than that of their Otomi neighbors. The finished sheets measure approximately 22 x 55 cms. Papermaking is the woman's task, as it is among the bark-beating Lacandones of Guatemala, the Sumus of Honduras, or the *tapa*-making tribes of Africa or the Celebes. These women are so adept that they can "couch" a sheet of paper within twenty minutes.

* The *Moral* is undoubtedly the *Tlacoamatl* of Hernández. "Es un arbusto con hojas como de moral, pero angulosas, y fruto parecido al del otro Tlacoamatl o sea el amacapolin, comestible y de las mismas propiedades, nace en todas partes, pero principalmente en lugares calidos."[5]

THE AZTEC AND MAYA PAPERMAKERS

The Aztecs of Chicóntepec use almost the same papermaking plants as the Puebla Otomis: *Ficus padifolia,* here called *cilmatl, Ficus involuta (tecomaxochiamatl)*, the nettle *Urera baccifera (teotzitzicaztli)*, the mulberry, and one non-Moracea – the bull's horn acacia, *Acacia cornigera.* The inclusion of this acacia (*huitzamamaxalli*) is due to the increasing scarcity of the wild fig. It yields a coarse, thickly-fibered paper, more difficult to fashion than the fig tree variety, but it is known also as *cuah-amatl*, the name once reserved for the product of the *amatl-*tree. It is a remarkable confirmation, for the Indians of today who are using the unique technique of the most advanced of all primitive papermakers, the boiling of the fibers in lime-water and subsequent felting of them into sheets, are the paper-heirs of the natives of Amacoztitlan who came very close to the paper mould and the technique of true papermaking invented by the Chinese.

Thus do the modern primitives tell us of the past. And yet, added to this confirmation, there remains the evidence of the remaining Aztec and Maya Codices. The paper-search has now carried us from the arrival of Cortés to the counting rooms of the King of Spain, from the book-burning ceremonies of Zumárraga and Landa to the bark-cloth makers of Central America. The Otomi papermakers have left us their story – and now the ancient codices of the Maya are about to reveal theirs; we are in a laboratory and the fibers of the Dresden Codex are about to give up their age-old secret – the secret of their origin.

The Fibers of the Amatl

In the winter of 1910 Dr. Rudolph Schwede was assigned to examine the fibers of the Dresden Codex, which had lain for a hundred and fifty years in the Royal Library of Dresden, marked with the pencilled notation, "made from *maguey* fiber." To many, the action of prying loose a few strands from the famous codex seemed a waste of effort. Humboldt, reproducing several of its pages in his Atlas in 1810, had stated that it was made from *maguey,* and no one had questioned this. But nearly a century later in Guatemala, Erwin Dieseldorff had examined a reproduction of the Dresden Codex and had written the Director of the Dresden Library that in his opinion, borne out by long researches in the heart of Mayadom, the codex was not and could not be made from the fibers of the *maguey*. That ushered in Dr. Schwede of the Technische Hochschule who undertook to pry into the fibral structure of its pages.[1]

The Dresden Codex, eight inches wide and twelve and a half feet long, folded screenwise in a single continuous piece, is covered on both surfaces with a white film or coating. This was the size, a sort of glaze that had excited the interest of Pietro Martire when he examined the "books" brought by the envoys of Cortés. Near the edges the fibers were somewhat loosened and here one could see the thick, irregular tangles of a yellowish-white color. The librarian surrendered a

few of them for examination, but never before had the Codex been subjected to such sacrilege since it had been given to the Royal Library in 1744.*

Schwede touched the fibers with a weak iodine solution, and this brought out dark-colored starch crystals of various shapes and sizes. Insoluble in water, the crystals were easily dissolved in carbonic acid upon liberation of carbon dioxide and when treated with sulphuric acid, were transformed into gypsum-spicules. This proved that the paper was not coated with gypsum, as Pietro Martire and many after him had stated, but with some form of calcium bicarbonate. Later microscopic examination suggested that it was of vegetable origin.

The fibers were pulled apart under water by means of teasing needles and under the microscope showed up wavy and interlaced, generally with thickened cell walls, the lumina narrow and sometimes hard to distinguish. Occasional thin-walled ribbon-like fibers with wide lumina also appeared. A striking peculiarity of the individual fibers was their being enclosed in sheathlike tubes which generally lay close and followed the fiber outline, but sometimes bulged away from it in rounded or pointed distentions and often extended far beyond the ends.**

These tubes are characteristic of all the Moraceae, the family to which the fig and the mulberry belong. They are the carriers of the milklike sap which pours out whenever these plants are cut, and which, in primitive papermaking, is soaked away and the residue, the gummy latex, scraped off. The fibers of the Dresden Codex, when placed beside those of a living fig tree, proved to be identical. Fur-

* The Dresden Codex was first found in the hands of a private owner in Vienna in 1739, by Johann Christian Goetze, Director of the Royal Library at Dresden. The owner presented it to Goetze as a mere curiosity, "incomprehensible and hence valueless," and Goetze, who was fully conscious of its value, presented it to the library.

** Note: Examine the microphotographs at the end of this book which were taken of these fiber-tubes.

ther experiments with iodine solutions showed the tubes remaining colorless or turning slightly yellow, while the inner fibers turned red. Upon admixture of sulphuric acid the former took on a light blue, the latter a dark blue coloration; phloroglucin and aniline sulphate caused no reaction; the fibers were thus seen to be non-wooded, a characteristic of the fig and the mulberry but not of the *maguey*. Chemically, histologically and botanically it had now been proven that *"die Annahme, dass dieses Papier aus den Blattfasern einer Agave hergestellt sei, sicher nicht zutreffend (ist)"*[2] (the supposition that this paper is made from *Agave* fibers is certainly erroneous).

One more result of the chemical tests should be mentioned: globules of glue between the layers of fiber, as though laminae of beaten bark had been stuck together in order to give more weight to the paper sheet. Francisco Hernández had spoken of a glue used by the papermakers of Tepoztlan. He called it (and the plant that produced it) *amatzauhtli, seu glutine papyraceo,*[3] the papyrus glue. Pietro Martire had admired the virtuosity of the pasting in the first codices to reach Europe, pronouncing it equal to that of "a skilled bookbinder."[4] The *amatzauhtli* is abundant in the vicinity of Tepoztlan. Dr. Robert Redfield has suggested that this may have stimulated the papercraft there.[5]

The sizing which Schwede had proved to be not gypsum but a starchy substance, probably of vegetable origin, was the "white luster" noted by Landa, "on which they (the Indians) could write perfectly well."[6] The Mayas may have made it from corn or manioc, as the papermakers of the Orient got starch for coating paper from the tubers of the manihot or the maranta (*Hibiscus manihot* and *Hydrangea paniculata*).

Having proved, in regard to the Dresden Codex, the truth of Pietro Martire's brilliant pronouncement that the paper was made from the inner bark of a tree, Schwede next turned his attention to the two other Maya codices, the Tro-Cortes-

ianus of Madrid and the Peresianus of Paris and subjected their fibers to the same thoroughgoing analyses. The results were precisely the same. Dr. Schwede had dissipated, once and for all, the notion that the Maya codices are "made from the fibers of the *maguey*."

The question of the Aztec codex fragments' was next taken up. It was the opinion of both Valentini[8] and Starr[9] that the Mayas made their paper from the bark of *Ficus elastica* but that the Aztecs made theirs from the "leaves" of the *maguey*. Dr. Schwede* made all the tests on the fibers of twenty-three distinct Aztec codices.**

And the conclusions? The paper of the Aztecs also was made from the bast fibers of the *amatl*-tree; in not a single fragment was the paper made from any other substance than the wild fig tree. From the chemical laboratory, which eliminated completely the personal equation of historians, came the conclusion: Neither the Maya nor Aztec made paper from the *maguey*. On the contrary, their paper was made from the inner fibers of the wild fig, confirming precisely the words of Pietro Martire in 1519 . . . *"Ex ficuum tabellis fiunt libelli."*

Examination disclosed that the fibers of the Maya codices – which were made from wild fig trees in the *tierra caliente* – differed in their histology from those fibers taken from the Aztec codices, prepared from the bast fibers of the fig trees of the *tierra fria*. It is then obvious that the paper of the Mayas came from the species in their own lowland areas, while that of the Aztec fragments was always from those that grew on the plateau and hillsides. Comparative study of processes and techniques permits us to conclude that the Maya preceded the Aztec. The Aztecs improved upon the Maya methods. In order to create a non-blotting sur-

* See Appendix. Page 102.

** Fibers taken from paper made by the modern Otomis and examined by the present writer were found to correspond with those of the Maya and Aztec codices and with those of the *Ficus* of the central plateau of Mexico.

face, they used stone, flatiron-shaped *planches** which, when heated and pressed upon the paper, closed the pores, and gave it "surface," which is more or less the same technique that European papermakers during the Renaissance used in their burnishing, by means of an agate-stone.

So, the last of the mysteries and contradictions have been dissipated. We know how the paper was made, and from what it was made, we see how the American papermakers have taken their place in the general phenomena of the evolution of culture. Now we come to paper as tribute, for it is written:

"Twenty-four thousand *resmas* of paper were to be brought yearly as a tribute to the storehouses of the ruler of Tenochtitlan."

* *Planches* (irons) actually stone-celts fashioned into the shape of irons. This is one of the most common archaeological artifacts in the Valley of Mexico. *See illustrations of these "planches."*

The Geography of Paper Tribute

Primitive American paper has now been examined from its sources and its manufacture. Yet, aware that in ancient Mexico it was made in such immense quantities that single villages delivered 24,000 reams annually as tribute to the Aztec overlords, we must attempt to determine its function in their cultural development, as well as the part it played in statecraft and conquest, in national economy and religion. We have seen it being made from the inner bark of trees in the past and the present, and we know what trees these were. Three types of evidence, unearthed from researches assist in forming a picture of the society which paper helped to nurture.

The first, and the most direct and helpful, is the Codex Mendoza,[1] which has preserved for posterity one of the tribute rolls of Montezuma. Recorded upon it with unmistakable ideographs are the villages that paid paper tribute to the Uei Tlatoani at Tenochtitlan: this is the pictorial and the "official" evidence. There follow the stone bark-beaters, which we now know were fashioned for the specific purpose of transforming bark into paper. They are found in various cultural strata at Teotihuacán and in the states of Morelos, Mexico, Guerrero, Oaxaca and Vera Cruz; the official evidence is thus supported by the solid evidence of archaeology. Last comes the green world of plants and the distribution of the "paper-trees."

From this synthesis the Aztecs emerge with clearness, but what of the people of

Yucatan? A pall of obscurity hangs over the Mayas. They were papermakers, and they were book-makers, yet here we have no tribute roll to assist us in solving the question: whence came the *huun*-paper from which they formed their genealogies and sacred almanacs, which they called *analteh?* The Maya area was vast. It included in its various epochs (from the prehistoric period to the League of Mayapan in the thirteenth century A.D.) the cloud-bathed regions of El Petén, the jungle-covered land of what is now British Honduras, Campeche, Tabasco, Vera Cruz, Chiapas, and Quintana Roo, and the limestone-bound peninsula of Yucatan. Here the wild fig, the "paper-tree," is everywhere. Yet, since Diego de Landa did the cultural history of man the disservice of burning hundreds of Maya-made documents, we can do no more than deduce from the physical evidence on hand which tree or trees were utilized. There are nine known species of *Ficus* in the Yucatan area, species which are repeated in the Mayan countries everywhere, with increase in variety and number in the jungle-wrapped areas. Of the nine,* two are most common, *Ficus cotinifolia* and *F. padifolia.* The leaves of the former, called *chimon* in the Motul dictionary, occupied a quasi-sacred place among the Mayas, and were scattered in the temple courts in Maya ritual. Since it is found in and about the peninsula of Yucatan in abundance, and since the fibers of *F. cotinifolia*** agree structurally with those of the Dresden Codex, we cannot be far wrong in

* Ficus cotinifolia

padifolia	radula
laevigata	yucatanensis
lapthifolia	bonplandiana
mexicana	involuta

Three well-known species of mulberry found in this area may also have been paper-trees: *Morus alba; M. nigra; M. rubra.*

** "The tree most likely to have been used was the *Ficus cotinifolia.*" R. L. Roys, *The Ethnobotany of the Maya.*

[67]

assuming that it was from this large tree of the gray bark that much of the Maya *huun*-paper was fashioned. The same may be said of *F. padifolia*. This large tree of pale yellowish bark "is the most abundant and widely dispersed of the American strangler figs."[2] It begins as a vine, strangles the host plant, and with age develops a large trunk and many branches from which aerial roots descend and enter the ground, giving rise to new trunks and forming a tree of the Asiatic banyan type. These aerial roots that penetrate the earth and enlarge themselves into ground roots may well account for Diego de Landa's reference to Maya paper as being "made from the roots of a tree."

In dimmest antiquity, when the Indians poured into the Maya area, they fashioned (as many of the Indians in the same area still do) their bark-cloth garments from the trunk bark of the wild fig. This is the method universally adopted by primitive tribes everywhere. As bark-cloth began to function as paper, as it left their backs to be replaced by cotton garments, as the demand for paper grew with their cultural growth, the felling of the whole tree became a technique which was doubtlessly frowned upon by their leaders, since it would inevitably bring about, as it has in many places, the disappearance of the tree. They then turned to the branches and, no doubt, to the "aerial roots" of such a tree as *F. padifolia*. This tree, incidentally, was pointed out to the present writer as *huun-chak*. Since *huun* is paper and *ak* is vine, and as this particular tree begins as a vine entangling its host-plant in its serpentine tentacles, the word *huun-chak* may be considered direct etymological evidence that paper was made from its bark. Its smooth, branchless aerial roots are sometimes thirty feet long and four inches in diameter and, as the Maya "books" were six to eight inches wide and as much as thirty-four feet in length, an aerial root, from two to four inches in diameter, could easily furnish a piece of bark which could be extended by beating, to a single piece six to eight inches wide and over thirty feet long, like the Jicaques of Honduras[3] today, who use the branches and aerial roots of the *Ficus* tree and from them strip

the *Ficus* bark in order to make their paper. So we have a botanical factor which determined the *huun*-paper technique: the long sheet of beaten paper suggesting the form of a book. In order to use it expediently the Maya craftsmen folded the paper screenwise, to look something like a modern railroad time-table, so that such books may either be looked at leaf by leaf or stretched out to their full length.

In the cultural history of paper, the folded book everywhere appeared late. The Egyptians rolled their papyrus. It was a cumbersome method which subjected the paper to rapid deterioration. However, the roll was used for over a thousand years until Callimachus, custodian of the Alexandrian Library, began in the third century B.C. to fold the papyrus sheets into books. Even after the invention of paper, up to the ninth century, books were rolled in China.[4] It was not until the Tang dynasty that the stitched tome began to appear; then, as with the Mayas, the book was folded screenwise. Thus the Mayas were not only folding books similar to those produced by the true papermakers, the Chinese, but they even made covers for them, covers at both ends, of wood or hide, to which later were added valuable stones anticipating the "jeweled" bindings of mediaeval Europe.

We have no precise knowledge regarding the age of the papercraft among the Mayas. Probably some of the books burned by Landa and other zealots contained legends, clues, or even historical data which would have told us much on this subject that now we may never know. But we do know that as early as the third century B.C. the Mayas were engraving calendars on stone. When did they begin committing their calendars to paper? We do know that after 889 A.D. the Maya stopped erecting their dated stelae. Henceforth all these important records were kept on easily handled paper codices. This date, 889 A.D., we may seize with certainty as the coming-of-age of the paper-world of the Mayas. But were they the first Americans to make tunics of bark and paper of bark, crafts known to all Middle-American nations? We do not know. A growing mass of evidence supports the theory that the culture of the Mayas not only was the oldest of the Middle-Amer-

ican civilizations, but also the purveyor of higher cultural elements to the rest of Middle America and Mexico.

The Middle cultures of Mexico were first in contact with the Mayas in the third century A.D. Eventually, although centuries later, they overran and dominated them. Like the Mayas, the Toltecs and Zapotecs of the Mexican plateau had hieroglyphic books, folded, fashioned, and used like theirs. They exist only in tradition, for none are known to have survived the conquest. If the date 660 A.D. ascribed to the famous *tonalamatl* of Huematzin is correct, the Toltecs were close upon the heels of the Mayas in the use of paper for books. Now the Toltecs and the Zapotecs occupied in the main that part of Mexico known today as Oaxaca and Chiapas. Fig trees abound there, and stone bark-beaters have been found in large numbers. A Oaxacan village, Amatlan, (Place-of-the-paper-trees) later became a paper-tributary town to the Aztecs when they became lords of Mexico.

Six species of *Ficus* are known in Oaxaca. Of these, four, from an examination of their fibers, are believed to have furnished the papermakers with bark for their paper. Since their tribute to the Aztecs was in paper rolls, it is assumed that *Ficus padifolia* (the fig whose aerial roots drop to the earth), and the *bonplandiana,* known to the Aztec as *iztacamatl* (*amate blanco*), furnished much of the *amatl*-paper whose long white rolls were offered up to the insatiable demands of their overlords.

It was under the aggressive policy of the *Uei Tlatoani Itzcoatl,* in the fifteenth century A.D., that the Aztecs overflowed their lake boundaries in all directions to establish their dominion over tribes near and far, and to organize their system of tribute of which paper was so important an item. It was under this Itzcoatl's rule (1428–40) that the gigantic temples in Tenochtitlan were built, causeways thrown over Lake Texcoco, and priestly ritual elaborated. Paper with the Aztecs already had, as with the Chinese, its magical, sacred aspect. Itzcoatl enabled the Tenochca to assume Aztec civilization, but it was under Montezuma I,

surnamed Ilhuicamina, the Wrathy, that the Aztecs moved into what is now Vera Cruz, Morelos, Guerrero, Puebla, Hidalgo and even down into Oaxaca. From villages in all these states *amatl*-paper was tribute. The first accretions of paper

The symbol of the papermaking village of Itzamatitlan (Morelos). The paper roll is topped by an Itztli – a black obsidian dagger meaning that its paper came from the Itzamatl, the paper-tree whose leaves were shaped like Itztli-daggers. This is the *amate prieto* of modern Mexico, *Ficus cotinifolia*.

came from Morelos, seat of the Tlahuica tribe, adjacent to Aztec territory. The tribal seat of Quauhnahuac (Cuernavaca), Amatitlan, Tepoztlan, and a group of villages, including Amatlan, were paper-yielding centers, as well as the villages of Huaxtepec, Yautepec, and Itzamatitlan on the Río Yautepec: all produced paper in abundance. In addition there was the papermaking village of Amacoztitlan, on the Río Amacuzac, in the valley which was the first to produce paper in "sheets," indicating a change of technique. This region was the authentic primitive paper factory of ancient Mexico. Separated from the Valley of Anahuac by a steep escarpment, much of the state lies below 5,000 feet and embodies all climates, particularly in its southern end where it dips into the region of the *tierra caliente*.

Many species of *amatl* the "paper-tree" are found here, growing beside streams, atop lava beds, or in the deep ravines of the valley. And here again are the grooved bark-beaters used in this ancient paper industry—the commonest pre-Columbian artifacts found in the valley.[5]

Of the many wild figs that are found abundantly in Morelos, three species, we know with certainty, yielded their bast fibers for paper: *Ficus cotinifolia, F. petiolaris, F. padifolia. Cotinifolia,*[6] important in Mayan papermaking, was equally so among the Tlahuica. It was known to them as *itzamatl* (hispanicized as *amate prieto,* black *amatl*), because its leaf is shaped like a dagger of black obsidian, *itztli.* The village below Huaxtepec on the Río Yautepec was called Itzama-titlan (Place-of-the-black-fig-trees). It delivered every six months 8,000 resmas of paper.[7] The heraldic rebus symbol of the town is a roll of *amatl*-paper topped with an *itztli.* The *itzamatl amate*[8] is widespread not only in the hotter zones of Morelos, but throughout all Mexico.

Ficus padifolia, the most widely distributed of all the figs, of primary importance, as we have seen, for Mayan papermaking, abounds in the humid areas. Among the Tlahuica it was known as *amazquitl.*[9] Growing principally along rivers and lagoons, it was the *amate* from which such papermaking towns as Ama-titlan, Amatlan, and Huaxtepec took their fibers. It is specifically mentioned by Hernández as "papel del madroño" (seu unedone papyracea).[10] The third and most important of all the papermaking trees in the Tlahuica country was the *amacoztic* (tree-of-the-yellow-paper), hispanicized as *amate amarillo.* It had many other names, such as *tepeamatl* and *texcalamatl.* The meaning of the first is obvious, since *tepe* (*tl*) is mountain, and this species of *Ficus* has the peculiar habit of clinging to rocks, as will be seen in the photograph* taken in the mountains of Tepoztlan. The term *texcalamatl* refers to another of its peculiar growth-habits, that of growing in lava (*tezontli*) beds. Hernández describes the *Ficus petiolaris* very well:

* See plate 7.

"It is the *Amacoztic,* which some call papyrus of the rocks . . . the tree clings to the rocks with great tenacity, in a marvelous way. . . . It thrives in Chietla (Guerrero), in mountainous and rough localities. It clings to rocks . . . hence its name *tepeamatl."* From the *amacoztic* came paper made not in rolls but in sheets, and Amacoztitlan (town-of-the-yellow-paper) was one of the main centers of this type of tribute. The technique for making paper in sheets, as observed by Hernández, was identical with that of the Otomis of today. This suggests that even then the tree was growing scarce. Large strips of bast fiber, taken from trunk or large branch were no longer available; the technique changed to meet the conditions. As with the Otomis, the small strips were washed, beaten, joined together, felted by pounding. The sheets, according to Hernández, were two dodrans (18 inches) long and one and one-half dodrans (13½ inches) wide, and all this was clearly conveyed by the rebus drawing of Amacoztitlan, the town that yielded it. This drawing, it will be remembered, portrayed a sheet of yellow paper with a blue stream flowing beneath it.

In Vera Cruz, where there are ten or more species of *Ficus,** the Totonacs yielded paper from the town of Amatitlan. The Tlaxcalans, in their paper-village of Iztacamatitlan (Place-of-the-white-*amatl*-paper), traded rather than yielded paper. Many areas in Guerrero sent in considerable rolls of paper, notably Chietla, where the *Ficus* grows in abundance. The tribes living in what is now Hidalgo and Puebla** were well-known papermakers, and other villages, such as Yamanatitlan, Yacapixtla, and Amaquemecan (Amecameca), located in the modern state of Mexico, were famed for their tunics of *amate*-bark. Amaquemecan even

* *Ficus: glaucescens; segoviae; cotinifolia; tecolutensis; microchlamys; lapthifolia; padifolia; glycicarpa.*

** In Guerrero there are seven recorded species, probably many more: *Ficus segoviae; mexicana; petiolaris; lapthifolia; padifolia; lentiginosa; bonplandiana.*

had on its coat-of-arms a branch of the *amate* from which the large sheets of bark were pulled.

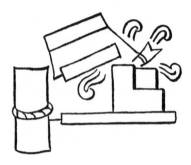

The town of Amatitlan in Oaxaca. Its symbol is a burning temple – indicative of its conquest – and attached to it a roll of *amatl*-paper. In the year III Acatl (1495 A. D.) the village of Amatitlan was subjected to a sharp, short conquest under Montezuma II. It contributed paper to Tenochtitlan until the coming of Cortés.

In the reign of Montezuma II, the long arm of conquest reached down into the land of the Mixtecs and Zapotecs, and in the year III Acatl (1495 A.D.) the village of Amatitlan in Oaxaca was subjected to a short, sharp conquest,[11] and was forced to yield long rolls of *amatl*-paper. The Zapotecs had had books as had the Toltecs;* that the papermaking technique was extremely ancient is evidenced by the presence of bark beaters in all archaeological deposits. Amatlan is in the Valley of Oaxaca, 1500 meters above sea-level.

Many species of *Ficus padifolia* are found there in profusion.** The papermak-

* The Toltecs, according to Nicolas Leon, called these books *amoxtli* (*amatli*), and the Zapotecs, *quijchitja-colaca.*

** Much of Oaxaca is in the *tierra caliente,* and the distribution of the strangler-fig follows that of other lands of that region (i.e., Vera Cruz and Guerrero). The species listed there are six: *Ficus: glaucescens; mexicana; cotinifolia; petiolaris; padifolia; bonplandiana.*

ing towns and villages varied in population from 150 to 5,000 inhabitants.* In almost all cases they paid other forms of tribute as well. All tribute was recorded on tribute rolls, and these were the first objects the Spaniards sought out upon the completion of their conquest.

"The kingdom was almost as large as Spain," Cortés wrote to his king, "Most of the Lords of these provinces resided in . . . the capital. The king had fortresses in all these provinces . . . also overseers and tax-collectors to see to the services and rent which each province owed him, and which was inscribed in characters and pictures on a kind of paper they have."[13]

So to those "provinces" that seemed to contain the most acceptable loot, Cortés and his men directed their attention. "In Montezuma's income books," says Bernal Díaz, referring to the tribute rolls, "we looked up which were the provinces from which he drew gold tribute and where there were mines, cacao, and cotton wraps, and thereto we wished to go."[14] Thus the conquerors familiarized themselves with the geography of tribute. So accurate were the documents that, upon assuming the mantle of Viceroy of New Spain, in 1535, Don Antonio de Mendoza, that "most illustrious and good knight and worthy of high memory," took one of them, now known as the Codex Mendoza, and had copies of it made on both European and native paper so that his sovereign might see the historico-social background of the "Aztec kingdom."

* Lopez de Velasco[12] gives the following figures:

Tepoztlan	2600
Yautepec	4000
Huaxtepec	4500
Yacapixtla	400
Amatlan	218
Amaquemecan (Amecameca)	5000
Amatitlan (Oaxaca)	150

The main copy, sent to Spain, was seized on the ocean by a French pirate and brought to Paris. There it was given to M. André Thevet, cosmographer to the King of France, who inscribed his name on its title-page, and, after thirty years of possession, sold it for five pounds sterling to Richard Hakluyt, Chaplain to the British Ambassador in Paris. Hakluyt brought it to London. For centuries it lay in the Bodleian Library at Oxford, an object of curiosity and interest. Raleigh wanted to include some of it in his *History of the World,* in order to show the riches to come from a reconquest of New Spain, but his head rolled off before he could accomplish it. Eventually, it appeared in Volume V of one of the elephantine folios of Lord Kingsborough's Antiquities.[15]

Yet this was only one of a long series of tribute rolls. Had not hundreds of them been destroyed by Juan de Zumárraga (for Bernal Diaz says that "Montezuma's rent-books occupied an entire house"), the geography of tribute could today be compiled with exactness. All we know from the general statement was that 24,000 *"resmas"* of paper was to be brought annually to the capital of the Aztecs. Considered as fragments of the immense quantities of paper that poured into the land of Tenochtitlan, it explains how much of the Aztec civilization when paper finally took hold was predicated on it.

The Paper-World of the Aztecs

A PAPER-WORLD had come into existence among the Aztecs. Inheritors of all the cultural growth of the civilizations that had preceded them, they had seen, even in their own, the evolution of bark-cloth to paper rolls on which priests scribbled magic signs, and further, to paper sheets and to books. Even as in Europe, when a paper-world finally came into existence, and after the printing press had developed into industry, to put a thing on paper became the first stage in thought and action. As a space-saver, a time-saver, a labor-saver, and so, ultimately, a life-saver, paper had a unique part to play in the development of industrialism. Yet, the Aztecs had an even more profound paper-world, for with them paper was, in addition, ceremonial. It had a spiritual quality similar to that which Dard Hunter ascribes to the Chinese:

"All classes of Chinese, from the aristocratic scholar . . . down to the most illiterate coolie, have a pronounced reverence for every scrap of paper, written, stamped, or printed. . . . 'Respect all written paper and treat it with care' ";[1] were the instructions regarding paper. And this, although not carried to its meticulous Oriental length, was more or less the attitude of the Aztecs.

Let us go back to the long line of tribute carriers winding along the great highway that led through deep valleys and over steep mountains to the high plateau where Tenochtitlan awaited their offerings. Some of the articles of tribute — corn, feathers, axes, copal, fibres[2] would speedily find their way to the market place,

where they were available to anyone who could produce a suitable equivalent in goods or cacao beans, or, sometimes, sifted gold. But the many hundreds of thousands of rolls and sheets of paper which weighed down the backs of large divisions of the carrier army were destined for special purposes of high social and religious importance. Writers, artists, and priests needed vast quantities of paper for documents and ceremonies; for tribute registers and trial records, for maps and genealogies, for historical annals and ritual calendars, for ceremonial dress and for sacrifices that went up in smoke each day before the altars of the special deity of those twenty-four hours. The chief function of paper was to placate the gods and to record, preserve and implement the power of the rulers. It was only after these high needs had been fulfilled that the residue of paper would reach the populace, and this residue, used by each individual in hundreds of rituals varying from month to month and almost from day to day, would bind him to throne and temple in a great unity of paper tradition and symbolism.

It was 10 Tochtli, Year 10 of the Rabbit, in other words, 1507 A. D., the year of the great New Fire Ceremony which the Aztecs were to perform for the last time in their history, that the carriers from Amacoztitla and Tepoztlan passed between the great summits of Popocatépetl and Ixtaccihuatl, over the causeways spanning Lake Texcoco, and poured into the Aztec capital.

"Although socially and governmentally Tenochtitlan was distinctly an American Indian tribal town, outwardly it appeared the capital city of an empire. A bird's eye view would have revealed an oval island connected with the mainland by three causeways which converged at the center of the city. These roads were cut by waterways over which removable bridges extended. The edges of the island were fringed by the green of the 'floating gardens,' while, at the center, the shiny white houses predominated and the verdure was reduced to tiny green squares in the patio gardens. Thrust above the quadrate masses of the roof tops loomed the various clan temples, each set on its platform in the form of a truncated pyramid.

The city had few streets or open spaces, but was gridded with canals crossed by portable bridges. The two principal plazas were those of the Temple of Tlaltelolco and the religious center of Tenochtitlan proper. . . .[3]

The Indians from the tributary villages were struck with wonder at the richly varied scene. Boatloads of produce were being poled along the waterways by farmers from the outside. As the carriers neared the city proper, the white walls of well-kept adobe structures appeared increasingly among the poorer wattled dwellings of the lower castes. Merchants from near and far walked by with other carriers flanked by soldiers and loaded down with merchandise. They passed temples where wretched human victims were about to be immolated, temples reeking with the stench of dried blood which contrasted with the pleasant and lively smells that came from the *Tianquistli,* the great market.

The *Tianquistli* was a busy hive, swarming with human bees. Every trade and every commodity had its separate street. Wares of gold and silver, cotton textiles and feather work, cacao, ropes, sweet-root, stone and wooden stamps for decorating pots and weaving, beans and corn, great earthen jars and small mosaic pitchers, skins of otters, jaguars, and pumas were displayed in profusion. In other parts of the market, tobacco was being bartered, as well as cochineal, obsidian knives, hatchets of copper and bronze, and stone celts of various shapes. Paper was offered, too — paper in rolls and sheets, paper in smaller pieces tipped with copal, tipped with hule-rubber drops, cut into flags, paper fragments to pin on some god as an act of homage.

The tribute carriers came to a halt in front of the building where the *Calpullec* performed the duties of secretary-treasurer and kept the economic order within the kinship. There the paper was unloaded and the carriers allowed to disperse.

Now the paper entered upon a new phase. We may assume that the finest and whitest was reserved for the great codices of which only fragments have come down to us, for the calendars, histories, and all the other writings that were under

the jurisdiction of the state. The remaining sheets and rolls and paper scraps and fragments of various shapes and sizes appeared in the market place where we have already seen them, and became the common heritage of all. They were of the utmost importance in the religious life of the people and in constant use among them.

Our detailed knowledge of the popular ceremonial use of paper we owe to Fray Bernardino de Sahagún (who may be classed with Hernández, the first European naturalist of the New World, as its first anthropologist and the most remarkable American historian of his time). Sahagún was a Franciscan monk who taught at the famous Indian College of Santa Cruz at Tlaltelolco and held many important positions in various establishments of the Order. He came as a young man and lived to be ninety. During all those years he diligently studied first the Aztec language, becoming pre-eminent in this field, and then the history, customs, manners, beliefs and skills of the Indians, amassing priceless notes and documents for his great work, "History of the Things of New Spain."[4]

Like Hernández, he got his information from the natives, from his students, many of whom were deeply versed in Mexican lore, from Aztec teachers and grammarians, and from chiefs and other important officials "well versed in local matters, in warfare and politics, and even in idolatries,"[5] as he says in the Prologue; and these data he checked and re-checked, revised and re-revised with unending care and devotion. It is the idolatries that interest us especially here, as they involved in the Calendar Festivals, the myriad applications of paper to ceremonial costume, ritual, and sacrifice.

In a chapter entitled "The Gods Which Ancient Mexicans Adored,"[6] Sahagún tells us that "Yiacatecutli, god of merchants, started trading among those people, and . . . for that reason the guild of merchants adopted him as their god and honoured him in different ways, one being to offer him *paper,* with which they

covered his statues. . . . Napatecutli is the god of those who make cypress (rush) mats. . . . The image of Napatecutli represented a man dyed all black, except for a few white specks in the . . . face. He wore a crown of *paper* painted black and white . . . in the left hand he held a shield fashioned like a water-lily . . . in the right hand he held a flowering stalk . . . the flowers being made of *paper.* . . ."

In the chapter "Feasts and Sacrifices with which the Natives Honoured their Gods," we read of the multitudinous strange and ghastly rituals in which *paper* was used.

"The Aztec months, which in all were eighteen, were each dedicated to a god. . . . The thirteenth month was Tepeilhuitl, in the course of which they honoured all the prominent peaks all over this New Spain. . . . When the festival in honour of the mountains commenced, they killed four women and one man . . . they dressed these women in many *papers* covered with ulli (gum) and carried them in litters borne on the shoulders of richly dressed women to the place where they were going to kill them. . . . The sixteenth month . . . Atemoztli . . . they celebrated the festivals for the gods of rain, because for the greater part of this month thunderstorms came up and rains began to show. When the festival was due . . . they cut *strips of paper* which they tied or wound around long slender poles and stuck these poles in the courtyards of their houses. . . .

"Such feasts as the above were permanent . . . the others were mutable, and were celebrated in the course of the twenty signs which completed their circuit of 260 days. . . .

"Under the sign of Cequiavitl they celebrated the festival in honour of the goddesses they call Cioapipilli, said to be the women who died giving birth to their first child. . . . They became goddesses and lived in the house of the sun. . . . In oratories erected in the streets . . . they kept the images of these goddesses . . . adorned . . . with *paper* which they called amateteuitl. . . . Under the sign of

Ceytzeuintli, which they said was the sign of fire, they celebrated a great festival in honour of Xiuhtecutli, god of fire . . . they adorned his image with *many kinds of paper* and with a great deal of rich ornaments. . . ."

During the Calendar Festivals paper was used in the following ways: "Under the first signs of the first month of the year, called in general Quaviteloa and by the Mexicans proper, Atlcaoalo, they celebrated a great festival in honour of the gods of the water, which they called Tlaloques (Tlalocs). At this . . . festival . . . they killed a large number of children on mountain tops. . . . They erected in all houses and palaces, poles on the points of which they fastened *papers** thickly sprinkled with ulli . . . drops. . . . The children sacrificed on the first mountain were adorned with *paper* dyed red. . . . On the second mountain . . . they dressed these with *papers* dyed black with lines drawn with red ink. . . . On the third mountain . . . they killed a girl . . . dressed with *papers* dyed blue. . . . On the fourth hill . . . they sacrificed children . . . adorned with *papers* streaked with ulli oil . . . on the sixth place of sacrifice they dressed them in *papers* one-half red and one-half tawny . . . in the seventh place, the *paper* ornaments were tawny. . . .

"In the fourth month, Veytocoztli, they celebrated the feast of the god of the grain-fields . . . Tzintautl . . . they cut a cane (stalk) of corn and stuffed it with viands . . . they would also carry the ears of corn . . . put aside for sowing, to the Cú to be blessed. This corn was carried on the backs of young virgin-girls, wrapped in blankets, and on each ear they sprinkled a few drops of ulli oil and then wrapped each in *paper*. . . . The festival held during the signs of the fifth month, Toxcatl, they made an image of Vitzilopuchtli in dough . . . they adorned with the vestments of the god . . . they crowned him with a crown shaped like a basket, and over it a *paper* in the center. . . .

"They made still another ornament in honour of this god . . . which consisted of an enormous piece of *paper,* twenty fathoms (six feet each) long by one in

* Italics, the author's.

width, and one finger thick. This *paper* was carried by a number of strong young men in front of the image, holding it on either side. In order to prevent this *paper* from tearing, they mounted it on shafts or darts which they called teumitl, and these shafts or darts were adorned with feathers close to the arrow-head, in the center and at the end. . . . Arriving at the foot of the temple steps . . . those who carried the large *paper* again mounted ahead of the statue, and to prevent tearing it, those who climbed first at once began rolling up the *paper* with care, pulling out the arrow shafts as they proceeded, and handing them to the one whose duty it was to gather them in a big bunch. As soon as the statue had reached the top they placed it where it belonged on its throne or chair, and they laid in front of the platform the *roll of paper* securely tied, to prevent its unrolling. . . .

"At this festival all the young girls painted . . . their faces, adorned their arms and legs with red feathers, and carried certain *papers* flatly stuck (fastened) on sticks . . . these *papers* were painted with ink (dye). If they happened to be the daughters of chieftains or wealthy people, they wore, instead of the *paper,* very thin blankets called 'canaoc.' These *papers* or cloths on their sticks they carried on high like banners, and walked in procession with the other people to honour their god. These girls also danced, holding their *paper banners* in both hands, around the hearth. . . . The priests wore around their foreheads a sort of *paper disk* shirred in the shape of roses . . . they wore undergarments of *paper* called amasmaxtli. . . .

"In the sixth month, Etzalqualiztli, they held a festival in honour of the Tlaloques. . . . At sunrise the priests dressed themselves in their . . . ceremonial robes . . . on their back they carried a large round *paper flower,* like a shield, and on the back part of the head they wore flowers of *shirred paper* which stuck out from the head on either side like ears, in the shape of semi-circles. . . . During these . . . days the boy sacristans (sextons) prepared and made all the paper ornaments needed by all the priests and by themselves. One of these . . . was like a *paper*

flower, still another . . . was a bag or pouch in which they carried incense. This pouch, made of *paper,* was bought at the tianquiztli (market); . . . the bags of the high priests were made of tiger skin, those of the minor priests were of *paper* painted to represent tiger skin . . . the priests took all the offerings of *paper,* plumes, precious stones . . . and carried them to a certain place in the lagoon called Pantitlan. . . . Along with these objects they also took the hearts of the sacrificed captives in a big earthenware jar painted blue and dyed with ulli on four sides; the *papers* above mentioned were also spotted with that gum. . . . After the hearts they also threw in the precious stones and the sacrificial *paper.* . . .

"In the seventh month, Tecuilhuitontli, a festival and sacrifice were celebrated in honour of the goddess of salt . . . worshipped . . . by salt-dealers. . . . When she danced, in one hand she carried a round stick on the top of which were three *paper flowers* . . . arranged in the shape of a trefoil . . . these flowers were filled with incense. . . .

"The tenth month was called Xocotlvetzi. As soon as the festival of Tlaxochimaco was over, they cut a big tree in the forest . . . the priests in their vestments and ornaments adorned the tree with *papers* . . . they put these *papers* on amid great noise and with much solicitude. A statue resembling a man and made of a dough of wild amaranth-seeds was also adorned with *papers.* The *paper* used was pure white, without paint or dye. On the head of the statue they fastened cut *papers* which looked like hair; on both sides they fastened *paper stoles* reaching from the right shoulder to the left armpit. On the arms they put *paper* fashioned like waves, on which were figures of the sparrow-hawk. He also received a *belt of paper.* Above this, other *papers* placed back and front simulated the vipil [Huipil] (blouse or shirt). On the sides of the statue and on the tree, from the feet of the former down to about the middle of the tree, long *papers* were hung, which waved in the air. These latter were about one-half fathom (three feet) wide by a length of ten fathoms (60 feet), more or less. . . .

[84]

"Then came those who had war-captives who were to be burnt alive. . . . The bodies of the captives were painted white, the belt (sash) which girded their loins was of *paper,* and they also wore stoles of white *paper* which reached from the shoulder to the armpit. They also wore hair (a sort of wig) made of small *strips of paper.* . . .

"At dawn all the captives were lined up . . . in front of the place called tzompantli . . . one of the priests at once began to take from them the *paper flags* they carried in their hands . . . which were the signs of their being condemned to death. They also took off the other *papers* they were adorned with, one or the other blanket, if they had covered themselves with one. . . .

"The twelfth month . . . Teutleco, which means the arrival . . . of the gods . . . they burned alive a great many slaves. . . .

"After having thrown the captives into the fire, the priests formed in procession, arrayed in *paper-stoles* from the left shoulder to the right armpit and from the right shoulder to the left armpit. . . .

"The thirteenth month was called Tepeilhuitl. For the festival celebrated in this month they covered certain sticks which they had previously shaped like snakes. . . .

"During this festival they killed a few women and one man in honour of the gods of the mountains. . . . They were dressed up in *paper crowns;* all the *papers* which adorned them were spotted with melted ulli. . . . The man called Milnaoatl, who . . . was the image of the snakes, also wore such a crown. . . .

"The fourteenth month . . . Quecholli . . . they took a cornstalk which had nine knots and placed on top of it a piece of *paper* like a flag or banner. . . . On the banner or flag they marked or embroidered with red thread a reel on both sides; they also embroidered the *long strip of paper* from top to bottom with well-twisted red and white thread. . . .

"The slaves who were to be killed in honour of the god Mixcoatl . . . also were

adorned with their *papers*. On the day of the festival they rounded up those who were to die and brought them in procession around the temple ... the slaves burnt all their wearing apparel, which consisted of a *paper* banneret, their blanket and their belt; ... On the day proper, at daybreak, they dressed them at once in the *papers* in which they were to die. ... Before each one of these slaves a *paper banner* was carried, and amid this accompaniment, every one was conducted to the temple. ...

"The fifteenth month ... Panquetzaliztli ... the women sang and danced, also intermingling with the men ... in front of the temple of Vitzilopuchtli, they poured a jug of water over their heads and over all the clothes they had on, men as well as women; then they took off their wet clothes and adorned them with the *papers* in which they were to sleep ... and also dyed their arms and legs pale blue; ... the slaves who were to be killed dressed themselves in their *papers*. ...

"All the captives walked at the head, and when they were ranged in ... order, a priest came down from the top of the temple and in his hands he carried a large amount of white *papers* which they call teteppoalli. ...

"They called the sixteenth month Atemuztli, which means the falling of rain. ... For five days previous to this feast, they ... prepared themselves by means of fasts and penances, to make the images of the mountains and cover them with *paper* ... on the eve of the festival they ... spent the entire night cutting *papers* in diverse shapes, and these, when cut, were called *tetevitl*. They glued them on long sticks or poles, from the bottom up, in the fashion of flags ... then they stuck these poles in the courtyards of their homes, each in his own, and there they stood for the entire day of the feast. All those who had vowed to make the image ... (of the mountains) invited the ministers of the idols to come to their homes and make (shape) the *papers* with which they were to cover (adorn) them. They made the images in the Calmecac and from there they took them to the houses of the people who had made vows, and at the same time they took their teponaztli, their jingles, and their tortoise-shell to play on. ...

"The seventeenth month was called Tititl, and during this month they killed a woman slave who was bought by the Calpixques. She was sacrificed in honour of the goddess Illamatecutli. . . .

"The goddess Illamatecutli . . . wore a mask with two faces, one in the back and one in front; the mouths . . . were very large and the eyes protruding; on the head she wore an embattled *paper crown*. As the gods (i.e. priests dressed as such) went toward the Calpules, a sátrapa descended from the temple, dressed as a young man; . . . he carried the pulpy leaf of a maguey which was topped by a small *paper banner* . . . he went straight to the trough or basin called quauhxicalco, where there was a small box like a cage, made of torches, the top of which was *papered* like a tlapanco.

"The eighteenth month . . . Izcalli . . . the women who were to be killed carried their little bundles and their jewelry on their backs; likewise the men. They did not wear the *papers* in which they were to die; these were carried by a man in front of them, on a tripod, its top . . . like a globe resting on the tripod-feet, and altogether one-half estado high (1 estado . . . 1.15 yards). Over the globe . . . the *papers* were hung in their order, and this tripod was then carried by one man before the . . . slave who was to wear them. . . . Upon reaching the Cú where they were to be sacrificed, the slaves were dressed in the *papers* in the manner of the god Ixcocauhqui. . . .

"At dawn those who had to die were again adorned with their (respective) *papers*. . . . After all of them had been immolated, the principal lords . . . were ready to begin a very solemn dance, which was led by the king. All wore on their heads *paper crowns* resembling half-mitres, that is to say, they had only a point in front and none in the back; a very tiny mitre of *blue paper* embellished the nose and hung down as far as the mouth. . . .

"Those who, through the advice of their astrologers, were able to ward off a disease, chose a very lucky day, and on that day burned, in the hearth of their homes, a great many *papers* on which the astrologer had painted with ulli . . . the

image of all those gods who . . . had helped them to ward off that illness. The astrologer (after thus painting them) handed them to the man who made the offering, telling him the name of the god painted thereon; the man then burned all the *papers;* they gathered the ashes and buried them in the courtyard. . . ."

In the chapter on "Those Who Went to Hell and About their Obsequies . . ." we read about the use of *paper* in funeral rites.

"The very old men and the *official paper cutters* cut, adorned, and tied the *papers,* as was their duty, for the dead; they contracted (doubled) his legs and dressed him with those *papers,* then tied him and took a little water, which they poured over his head, saying to the deceased, 'This is the water you enjoyed while living in the world (on earth).' Then they took a tiny jar . . . they gave the deceased all the *papers* that had been prepared (for the occasion), placing them in orderly fashion before him, saying 'See, here is with what you are to pass (travel) between two mountain ranges which are joining with one another.' Moreover, they gave him other *papers,* saying to the dead man, 'See here with what you are to pass the road which is guarded by a snake.' Still other *papers* they gave him, saying, 'See here with what you are to pass the road over which the green lizard . . . roams, which is called xochitonal. . . .'

"When the dead arrived and stood before the devil, who is called Mictlantecutli, they offered and presented to him the *papers* they carried. . . .

"Thus, at the place of Hell, called Chicunamictla, the deceased finished and brought their wanderings to an end. . . ."

This was the paper-world of the Aztecs.

It was partly ritualistic, partly scientific, and partly literary. Everywhere in the Aztec world, as in the days of the European alchemists, the dross of charlatanism mingled with grains of genuine scientific knowledge. Yet, despite the primitive abracadabra that encompassed it, the impulse of investigation turned man's mind to the external world. Everywhere man refused to accept any natural environment

as a fixed and final condition of his existence. Fire made easier his digestion of food, and social life became possible "beyond the mere huddle and vacuity of the winter's sleep;" with *writing* and its corollary, *paper,* the continuation of civilization became possible by extending experience beyond the orbit of the individual who experienced it.

So man advanced in the vast cultural horizons of the world. The Egyptian, the Chinese, the Maya and the Aztec showed – without knowledge of one another – a fascinating parallelism. Yet, of all these civilizations, the American deserved the highest praise, since technically it was still wedded to the neolithic plane. In spite of this, it was able in many instances to supersede those other, older cultures which had the accrued benefit of metal. We cannot tell what Aztec civilization might have become had it not collapsed under the onslaught of the stronger civilization of Colón and Cortés. Its achievements could not save it and its weaknesses helped to destroy it. In the words of Prescott:[7]

"The Aztec monarchy fell by the hands of its own subjects, under the direction of European sagacity and science. Had it been united, it might have bidden defiance to the invaders. As it was, the capital was dissevered from the rest of the country; and the bolt, which might have passed off comparatively harmless, had the empire been cemented by a common principle of loyalty and patriotism, now found its way into every crack and crevice of the ill-compacted fabric and buried it in its own ruins. Its fate may serve as a striking proof, that a government which does not rest on the sympathies of its subjects cannot long abide; that human institutions, when not connected with human prosperity and progress, must fall – if not before the increasing light of civilization, by the hand of violence; by violence within and without."

Thus passed the first American civilizations into cultural limbo and with them, those anonymous and communal craftsmen, the first American papermakers.

Epilogue

FRANCISCO HERNÁNDEZ

1514–1577

Francisco hernández, native of Toledo, graduate in medicine of the University of Salamanca, physician-in-ordinary to the King, and proto-medico of the first scientific expedition to the New World, spent the five years from 1570 to 1575 in New Spain, in the twilight of Aztec civilization. During this expedition he and his Aztec assistants filled sixteen folio volumes with drawings and descriptions of plants and animals. He and his party were able to roam throughout Mexico, from the lush lowlands of Vera Cruz and Tabasco to the verdure-splashed hills of Puebla, Morelos, and Guerrero, and beyond, into the *tierra fría* of Tenochtitlan. Considerable time was spent also among the Tarascans of Michoacan.

The Mexico in which they moved had felt the hand of conquest for only fifty years; the Indians had not yet forgotten their extensive knowledge of plants, neither their names nor their manifold uses, industrial and medical. They were docile and serviceable, and of prime importance to the work of Hernández, who was well supplied with native interpreters, artists, and secretaries. In view of the official character and royal patronage of the expedition, he was able to command whatever he needed. By his vigorous initiative and powers of persuasion he had prevailed upon Philip II to permit him to organize and direct his great undertaking.

EPILOGUE

The collection of herbarium specimens was the most important phase of Hernández' work, and most of the published material – contained in the first eight books – is given over to what we should now call ethno-botany. His skilled native informants, from whom with the aid of his interpreters he collected all his data, knew not only the character synonymy of the Mexican flora, but its classification according to their botanical system, its glossology and taxonomy. All this, after sifting out the dross of Indian invention, Hernández put into his *Thesaurus*. He then had each plant illustrated, and these drawings, with the descriptions of the collected specimens, became the basis of his work. In all, he collected 3000 plants, which are reduceable to approximately 1000 actual species, producing a gigantic herbal on Dioscoridean lines, mostly from the plateau regions within the Aztec orbit. But he also had plants with Tarascan, Mixtec and Huaxtec names, which he had either collected himself or had brought to him; and of some plants he had only reliable reports. The most thorough of ethno-botanists today could do little more, and that is why one must – in the special instance of *amatl*-paper – peruse all of his material; for Francisco Hernández was an accurate observer.

The pursuit of flora and fauna did not always run smoothly. In Michoacan, Hernández became very ill. While trying to prove empirically the value of a native medicine he swallowed some of the latex of the plant known as *chupri,* later identified as the deadly spurge (genus *Euphorbia*), and for months lingered miserably between life and death. He had difficulties, too, with local politicos jealous of his authority and prestige; and then, at the end of five years, when the first stage of his immense task was completed, suddenly the money gave out, his royal patron having apparently forgotten his promise to finance the work to the end.

Resourceful Dr. Hernández went into private medical practice in Mexico City, and his patients had the unique privilege of receiving the doubtless eclectic treatment of one who had prescribed for kings and learned from Indians. By this means he earned enough to have his work translated from the Latin in which he had

written it, into both Spanish and Nahuatl. The fame of this second exploit filtered back to the Escorial, to the ears of Philip II. The King of Castille was up to his starched ruff in worries. Drake and Hawkins were loose on the Spanish Main, and the Plate fleets had been repeatedly attacked. The Incas were in revolt in Peru. The Armada was being prepared for a visit to Elizabeth's Isle. Still, Philip found time to consider the claims of Hernández and to be sufficiently impressed to send him 60,000 ducats. Though this was hardly enough to defray all expenses, the great work on the natural history of New Spain was soon ready for printing, and in 1577 its author returned to Spain with the natural expectation of seeing it through the press. Instead, the sixteen volumes of woodcuts, maps, botany, anthropology, and precious medical lore, were taken, bound, and – buried in the stacks of the royal palace.

After Hernández' death, in the same year, which was probably hastened by this treatment, the King suggested that an abstract be made of the compendium. This was turned over to Dr. Nardo Antonio Recchio of Naples. But scarcely had Recchio taken over a fragment of the material, when a conflagration destroyed most of Hernández' books, along with thousands of other precious manuscripts in the Royal Library. And hardly had Recchio extracted "the most important part" of the considerable fragment in his possession and started for Rome to attend its printing, when he also died, and the manuscript passed to his nephew Petillio who did not know what to do with it. In time the rumor of its immense interest and value came to the ears of Prince Frederico Cesi, Duke of Sparta, patron of science and founder-president of the Lyceum of Natural History at Rome. This discerning dilettante bought it from Recchio's heir and prepared to give it a complete overhauling.

It was not until 1612 that parts were distributed among specialists for new editing, arranging and annotating. Prince Frederico sent artists to Spain to obtain additional illustrations and assumed the expense of having woodcuts made from

the original drawings, some of which remained undamaged. He also wrote a remarkable epilogue for the proposed edition, entitled "Theatri Naturalis Phytosophicae Tabulae." This vague, rambling, exposition of a somewhat Aristotelian-Galenian conception of animals and generation, which has been compared to Bacon's *Novum Organum*, takes up a large part of the printed work. While it shows the author's enthusiasm for his subject, it belongs now only to the history of science.

In 1628 the manuscript was ready for the press. Undoubtedly the Prince intended to defray the costs. But then another of those accidents befell, which had attended the work throughout its history. Frederico died, leaving the printing as a sacred legacy to the Lyceum, unfortunately without the money to pay for it. Ultimately one of the members, Francesco Stelluti, sought out the Spanish Ambassador to Rome, Don Alfonso Turiano, and from him at last obtained the necessary funds.

So, in the year 1651, from the compendium of Recchio, with the annotations of the scientists of the Lyceum, the epilogue of Prince Frederico Cesi, and the commentaries of Fabio Colonna, what was left of the great work of Francisco Hernández, first naturalist in the American field, was finally printed in Rome, in one monstrous volume of 950 pages.

The American Fig Tree

BY PAUL C. STANDLEY

Field Museum of Natural History, Chicago

FIG TREES constitute one of the largest groups of trees of the whole world, with a wide distribution almost throughout the tropical and sub-tropical regions of both the Eastern and the Western Hemispheres. The species of greatest economic importance, *Ficus Carica,* the common edible fig of the Mediterranean region, is, perhaps as a result of long cultivation, the one most adaptable to climatic conditions; in North America it thrives far outside the Tropics; even, with a slight amount of protection, as far north as Philadelphia and the Ohio River. Indeed, in such temperate or sub-tropical regions as the southwestern United States and northern Mexico, to which the fig was introduced centuries ago by Spanish missionaries, it thrives much better than in truly tropical regions farther south.

The genus *Ficus,* to which the figs belong, contains probably more than 700 species. These are most numerous in the East Indies and in Africa, but the number indigenous in the Western Hemisphere is very large. Two species are native in the cypress swamps of Florida; about fifty occur in Mexico and Central America, ranging northward as far as Chihuahua, Sonora, and Lower California; approximately thirty-five have been reported from the West Indies; and in South America there must be at least 100 species. Probably the number native in South America is

considerably greater, since vast portions of the lowland forest, in which figs most abound, remain unexplored.

The genus *Ficus* is divided by botanists into five to eight divisions or subgenera, according to characters furnished by the "fruits," i.e., receptacles. These fruits supply the distinguishing character of the genus, separating it at once from all other members of the family Moraceae, and likewise from all other plants of the earth. They are so distinctive that there is every reason for keeping all the *Ficus* species in a single genus, rather than dividing them among several, as was suggested by some of the earlier writers.

The "fruit" consists of a fleshy, hollow, more or less globular receptacle that bears upon its inner surface numerous minute flowers of exceedingly simple structure, succeeded by equally minute fruits containing tiny seeds. These fruits are attached to the branch either singly or in pairs and they increase in size with age. At the base they are subtended by an involucre of two or more bracts. The fruit has at its apex a minute aperture, closed by closely overlapping scales, an opening so small that it is likely to be overlooked altogether in the common fig.

Isolated as the flowers thus are from outside influences, it is evident that they cannot be fertilized by ordinary external agents such as bees or other flying insects. It is of particular interest, and not altogether unexpected, to find that specially adapted insects exist for the purpose of assuring fertilization. There is a special group of insects inhabiting the fig trees, living normally within the receptacles, and transferring the pollen to the stigmas. As a result of their secluded existence, amounting almost to imprisonment, it is not surprising, either, to learn that the insects of the fig fruits exhibit extreme local specialization. It is even claimed by students who have investigated the fig insects of Costa Rica, that a separate species of insect occurs for each species of fig tree. Since the entomological work has not been correlated with neat botanical classification this statement is open to question, especially since some of the *Ficus* species are rather closely related.

The American fig trees all belong to two groups or subgenera of *Ficus, Pharma-cosyce* and *Urostigma,* both of which were long maintained as separate genera. In *Pharmacosyce* the fruits are usually large and are inserted singly on the branches; the involucre at their base is 3-lobed. The male flowers contain two stamens. The leaves of this subgenus are normally large and frequently scabrous, or rough, to the touch.

In *Urostigma,* the subgenus with much the larger number of species, the leaves vary from very large to very small, but they are rarely, if ever, scabrous. The fruits are not as large as in *Pharmacosyce,* and often minute, and they are inserted in pairs; the involucre is 2-lobed. The male flowers have only one stamen.

The Old World figs exhibit much greater variation than those of the New World, although many of them resemble American species very closely. In some Old World species the fruits are borne on the trunk or lower branches, often in large woody panicles. The leaves of the American species are always strictly entire, and thus altogether unlike the deeply lobed leaves of the ordinary cultivated fig.

Although fig trees often constitute a substantial percentage of the tropical for-ests, and attain a great size, they are among the least useful of all the trees of the world. Actually, the familiar edible fig, the best-known representative of the genus, which has been in cultivation for thousands of years, is the only member of the genus that has any real economic importance at the present time. Although often of such huge size, fig trees are despised by lumbermen, who either leave them standing when the forest is cleared or cut them and leave the trunks to rot upon the ground. The wood is worthless for most purposes, even for fuel.

The fruits of the American species vary greatly in size. In some, the fruits are no more than 5 mm. in diameter, while in others, especially the subgenus *Phar-macosyce,* they may attain 4 cm. or even more. In the smaller fruits there is so little pulp that they are scarcely fit for human food, and in America even the larger fruits are seldom eaten by man. The large fruits of such species as *Ficus*

glabrata HBK. or *Ficus radula* Willd (subgenus *Pharmacosyce*) are a mass of soft, sweet pulp and not unpleasant to eat.

The fruit of the wild figs, which is often produced in excessive abundance, is much sought by such animals as peccaries and agoutis, and particularly by such fruit-eating birds as parrots, macaws, and toucans. When the fruit is ripe, it is usually an easy matter to locate the trees by the chattering flocks of birds quarreling in their branches.

Many of the American fig trees are giants of the forest and form an imposing spectacle when they can be viewed alone, without encroaching vegetation. Those of the subgenus *Pharmacosyce* are usually much taller than the species of *Urostigma,* although there may be exceptions. They have corpulent trunks, covered ordinarily with a rather thin, almost smooth and conspicuously pale, often whitish, bark. The crowns of the trees are typically compact and dense and, when exposed to light, broad and spreading. The leaves are neat in form, thick and firm, often glossy, closely spaced, and free from imperfections. They remain upon the tree throughout the year, although the old leaves frequently fall in great numbers at the beginning of the wet season, when new leaves are most plentiful.

Because of their handsome appearance the native fig trees often are left for shade when the forest is cleared, or else are planted particularly for the purpose. The Salvadorians speak affectionately of the *amate* as their "national tree." The well-swept ground beneath their cool shade is the favorite gathering place for the inhabitants, as well as for all the domestic animals. The *amates* figure almost as prominently in the poetry and romance of tropical America as the beloved *ceibas*.

Certain Old World fig trees are planted commonly in America for shade, although they have nothing to recommend them above the native species.

Most common of all the introduced trees is one of the banyan figs, *Ficus nitida,* which may be seen almost anywhere in Mexico and Central America, as well as in the West Indies and South America. Like others of the genus, it is conspicuous

because of its habit of growth, at least when the trees have attained great age. From the crown numerous cordlike aerial roots depend, some of which lengthen until they reach the ground where they take root, ultimately forming trunks of considerable thickness at some distance from the main trunk. In their native lands such banyan trees often cover a large area and furnish shade sufficient for a host of people. Some of the American species, such as the widely distributed *Ficus padifolia* HBK., grow in the same manner when in a congenial habitat. Particularly fine examples of *Ficus nitida* may be seen in the delightful park at Limón, Costa Rica, but well-grown individuals are a common sight in many other localities, especially along the west coast of Mexico and Central America.

Perhaps the most curious feature of the fig trees, certainly the one most likely to attract attention, is the peculiar habit of growth that characterizes most, if not all, the species. They are normally, at least in their earlier stages of growth, epiphytes, existing upon some host tree. The small seeds doubtless are spread by birds, which deposit them upon some lofty trunk or bough. There the seeds germinate, producing a small plant that quickly develops slender aerial roots. These adhere closely to the parent branch and increase rapidly in length and thickness, finally reaching the ground. They cross one another and grow together, gradually forming a netlike body about the trunk and ultimately encircling it completely. Although the fig tree draws no nourishment from its host, the pressure of its increasing trunks is at last sufficient to strangle the latter and cause its death, after which the fig tree is able to stand alone, by the aid of its substantial trunk or trunks.

Again, particularly in such arid regions as Lower California and Sonora where there is a dearth of large trees, the fig seeds sometimes germinate on naked cliffs or huge rocks, where they behave just as if growing upon trees. Their interlacing roots may be observed there to even better advantage, their fantastically intertwined and twisted forms suggestive of nothing so much as writhing serpents.

This habit of growth is shared with trees of other genera of the mulberry family,

[*98*]

like the species of *Coussapoa,* and with representatives of certain unrelated groups of plants, such as the Clusias. A few of the fig species, so far as I have been able to observe, seem never to attain great size, but grow always as epiphytic vines. In this respect they resemble the Old World *Ficus pumila,* which creeps so thickly over old masonry or even upon old lumber.

When any part of a fig tree is broken, there exudes a sticky white sap or milk that soon coagulates and finally solidifies. The dried sap is elastic and has many of the properties of Hevea rubber. *Ficus elastica* was formerly well known as a producer of rubber, but in the quality of their product the figs are not able to compete with Hevea trees. It is, of course, quite possible that some use may ultimately be found for *Ficus* rubber, although probably a superior article may be obtained more satisfactorily from other sources. In some regions of tropical America fig rubber is employed locally for various purposes, as in treating dislocations and fractured bones.

By far the most interesting applications of the American fig trees are those formerly made of the bark. The fibrous nature of the bark of trees of the mulberry family is well known, such bark being a characteristic of probably the whole group. From the bark aboriginal and even semi-civilized people in widely separated parts of the earth have long made clothing, and fabric for other purposes. The fine quality of cloth manufactured from related trees in the Pacific Islands is widely known.

Because of the close relation between fig trees and paper, the words for these two objects became identical. The Aztec word *amatl* designated both paper and fig tree. The Tarascan word *siranda* is said to have the same two meanings.

Among the Spanish-speaking people in some regions, the Spanish words *higo* and *higuero* are now applied commonly to the native figs and to the trees on which they are borne. In Mexico and Central America, as far south as Aztec influence prevails, that is, to Costa Rica, the name *amate,* a hispanicized form of *amatl,* is

the name generally applied to the wild figs. It is doubtful that the unlettered countryman suspects any relationship between the *amate* of the forest and the *higuero* of the orchard. The word is preserved in many well-known place names: Amatitlan is the place where fig trees grow; Amatepec is the hill on which fig trees abound.

In Mexico, where the botanical vocabulary is more highly specialized than anywhere else in America, if not more so than anywhere else in the world, other names beside the more or less standardized *amate* are given to the fig trees. Unfortunately, too little still is known regarding the names applied to the various species of *Ficus*.

It may be worth while to list here some of the local names for *Ficus* species, with the hope that more careful investigators may try to rectify some of the errors and to obtain accurate data regarding the names actually in use. Besides *amate*, a name commonly employed in Jalisco and elsewhere is *camichin*, whose original meaning is said to be "eel," a reference to the snakelike roots of the tree. This name is believed to be given ordinarily to the small-fruited figs, such as *Ficus padifolia*. Likewise used in numerous regions is the name *zalate* or *salate*. The term *macahuite* employed in some regions of Mexico is presumably a corruption of *amacuahuitl*, "fig tree."

In Chihuahua, the name *salate* is reported for *Ficus radulina* Wats.; in Lower California it denotes *Ficus Palmeri* Wats.; in Sinaloa *Ficus michrochlamys* Standl. The name reported from Durango for *Ficus Goldmanii* Standl., *chalate*, is evidently a corruption of *salate*, or more likely an erroneous rendering of it. *Amatillo*, a Spanish diminutive of *amate*, referring doubtlessly to the small fruit, is reported as the Tabascan name of *Ficus panamensis* Standl. *Chilamate* is reported as the Oaxaca name for *Ficus petiolaris* HBK., which is called in some regions *tepeamate*, *tescalama*, *texcalamate*, or *amate amarillo*. The name *camuchin* or *comuchin* is reported only for *Ficus padifolia* HBK., a widely distributed and

somewhat variable tree, with small leaves and fruit. The same species is known also by the names *amatillo,* and *capulin* (Tabasco), *samatito* (Guerrero, Oaxaca, Morelos), *amesquite* (Morelos), and *jalamate* (Morelos). The name *amate* appears to be applied generically to most of the fig trees native to Mexico. It should be mentioned also, that the Spanish name *matapalo,* "tree killer," is applied commonly to these trees, a natural descriptive term alluding to their habit of growth.

Regarding Maya names for *Ficus* species, singularly little information is available. In Yucatan the Spanish name *alamo* is reported in use for several of the species and the name *copo,* possibly a Maya word, is reported by Maler as a Maya name for a Ficus species growing in Chiapas.

In Salvador the native figs have been studied rather intensively, and their vernacular names carefully compiled. The generic name for all the Ficus species is *amate,* which sometimes is qualified by Spanish adjectives. The name *chilamate* is sometimes given to *Ficus glabrata* HBK. and *Ficus padifolia* HBK., although this term is applied more commonly to quite another tree, *Sapium macrocarpum,* of the family Euphorbiaceae. The name *capulamate* is applied to various Salvadorian figs, but most often to *Ficus padifolia.* This name signifies "cherry fig," the term *capulin,* a modification of a Nahuatl word, being given in Mexico and Central America to a great many small red fruits that resemble more or less closely the Mexican cherry (*Prunus Capuli*). The name *cushamate* also is reported from Salvador for *Ficus padifolia,* and that of *salamate* for *Ficus radula* Willd.

Such is the complex botanical history of one of the most interesting genera of American plants.

Appendix

Aztec Codex Fragments Examined by Dr. Rudolph Schwede

1. Humboldt Mss. No. 2, dated 1565, *Mexico.*
2. Humboldt Mss. No. 7, dated 1571; *from Mizquiyahuallan, State of Hidalgo (Otomi).*
3. Post-Columbian Nahuatl Ms. *Peabody Museum, Harvard University.*
4. Dorfbuch von Ocryacac, *Königliche Bibliothek, Berlin.*
5. Manuscrit mexicain no. 222 *Bibliothèque Nationale, Paris.*
6. Manuscrit mexicain no. 81 *Bibliothèque Nationale, Paris.*
7. Codex Cempoallan Picture Chronicle. *Newberry Library.*
8. Drawing representing the conquest of Azcapuzalco, 1430, *Newberry Library.*
9. Genealogical tree, early 16th century. *Newberry Library.*
10. Map of Teotihuacan, early 16th century. *Newberry Library.*
11. Seler Manuskript No. 2. *Berlin.*
12. Ibid. No. 1 ("aus Agave-papier"), *Berlin.*
13. Ibid. Nos. 3, 4, 5, *Berlin.*
14. Ibid. No. 6 ("ein Stück Agave-papier"), *Berlin.*
15. Ibid. No. 7, Six-leaved Atlas, *Berlin.*
16. Ibid. No. 8, *Berlin.*
17. Ibid. Nos. 9, 10, Atlas-map, *Berlin.*
18. Ibid. Nos. 11, 12, Five-page Atlas-map, *Berlin.*
19. Ibid. No. 13 ("Agave-papier"), Three-page Atlas map, *Berlin.*
20. Ibid. No. 14 ("Agave-papier"), Three-page Atlas, *Berlin.*
21. Ibid. No. 15 ("Agave-papier"), Three-page Atlas, *Berlin.*
22. Ibid. No. 16. Blatt 8 des Atlas. *Berlin* (Seler says, it is Agave).

Notes

Paper and Civilization

[1] Edward King Kingsborough, *Antiquities of Mexico*. London, 1830–1848. Codex Mendoza. Vol. I. Plates 23, 26, 27. Vol. I. Text, p. 6.

[2] J. J. Valentini, *Mexican Paper*. American Antiquarian Society. October 1880.

The Paper Tribute

[1] Bartolomé de Las Casas, *Historia de las Indias*.

[2] George Vaillant, *The Aztecs of Mexico*. New York, 1941. p. 200.

[3] J. Eric Thompson, *Mexico before Cortés*. New York, 1933.

[4] George Vaillant, *op. cit.* pp. 108–113.

The Twilight of the Gods

[1] Bernal Díaz del Castillo, *Historia verdadera de la Conquista de la Nueva España*. Mexico, 1904. Vol. 1, p. 119–121.

[2] Salvador de Madariaga, *Hernán Cortés*. New York, 1941. p. 122.

[3] Bernal Díaz del Castillo also speaks of book-repositories: "At Cempoalla (Vera Cruz) . . . in some temples we found instruments . . . much plumage of parrots . . . AND BOOKS OF PAPER OF THE COUNTRY and folded in the manner of cloth of Castille . . ." *The True History of the Conquest of Mexico*. New York, 1927. p. 94.

[4] D. Lucas Alamán, *Disertaciones sobre la Historia de la República Megicana*. 1844. Tome I. pp. 91–191. Signed in name of Cortés. Procuradores' Puertocarrero y Montejo July 6, 1519 in which *paper books* are mentioned.

Pietro Martire and the "American Books"

[1] Prudencio de Sandoval, *Historia de la vida y hechos del Emperador Carlos V*, etc. Pamplona, 1614. Book VI, IV, p. 159.

² Bartolomé de Las Casas, *op. cit.* V. 65, Book III, pp. 105–113.

³ Salvador de Madariaga, *op. cit.* p. 300.

⁴ Salvador de Madariaga, *op. cit.* p. 300.

⁵ D. Lucas Alamán, *op. cit.* Tome I. pp. 99–101.

⁶ Salvador de Madariaga, *Christopher Columbus.* New York, 1940. p. 257.

⁷ As quoted by Hans Lenz, *La Industria Papelera en Mexico.* Mexico, 1940.

⁸ Petrus Martyr, *De rebus oceanicis.* Coloniae, Dec. 8, 1574. p. 354.

Paper . . . from the Inner Bark of Trees

¹ William Prescott, *History of the Conquest of Mexico.* (3 vls.) New York, 1843. Prescott deals with the burning of the books by Fray Juan de Zumárraga with great irony.

² J. Eric Thompson, *Mexico before Cortés.* New York, 1933. He gives the number of fourteen hieroglyphic codices that survive: five in England, four in Italy, two in France, one each in the United States, Austria and Mexico.

³ Frans Blom, *Conquest of Yucatan.* New York, 1936.

⁴ Diego de Landa, *Rélation des Choses de Yucatan.* ed. B. de Bourbourg. Paris, 1864. p. 44.

⁵ Frans Blom, *op. cit.*

⁶ Bernal Díaz del Castillo, *op. cit.* p. 94.

⁷ J. Wiesner, *Ein neuer Beitrag zur Geschichte des Papiers.* Sitzungsberichte der Kaiserlichen Akademie der Wissenschaften, Philosophisch-Historische Klasse. Vienna, 1904. Vol. 148, part 6.

J. Wiesner, *Ueber die ältesten bis jetzt gefundenen Hadernpapiere.* Sitzungsberichte der Kaiserlichen Akademie der Wissenschaften, Philosophisch-Historische Klasse. Vienna, 1911. Vol. 168, part 5.

J. v. Karabacek, *Das arabische Papier.* Vienna, 1887.

C. M. Briquet, *La légende paléographique du papier de coton.* Bulletin du bibliophile. Paris, 1884. pp. 498–507.

⁸ C. H. Haring, *Trade and Navigation between Spain and the Indies.* Cambridge, 1918. p. 309.

⁹ Diego de Landa, *op. cit.* p. 44.

[10] 1) "In Yucatan the books were made from the bark of trees and coated with a white and lasting resinous substance (betum)." Cogolludo, *Historia de Yucatan*. Madrid. Lib. LV, p. 185.

2) "paper was made from the bark of trees." Avendaño y Loyola, *Relación de las dos Entradas que hize a Peten Ytza*. Translated by Philip Ainsworth Means, *History of the Spanish conquest of Yucatan and of the Itzas*. Cambridge, 1917. p. 141.

3) "They made their paper from the bark (cortés) of trees." Juan Villagutierre y Sotomayor, *Historia de la conquista de la provincia de el Itza*. Madrid, 1701. Book VII.

4) "Bark." Sánchez de Aguilar, *Reports on the Maya Indians of Yucatan*. New York, 1921. p. 95.

5) "Libros hechos de cortezas de cierto arbol." Alonso Ponce, *Relación breve y verdadera de Algunas Cosas,* etc. 1873. Vol. XII, p. 382.

[11] Fray Alonso de Molina, *Vocabulario en lengua castellana y mexicana*. Mexico, 1571. p. 159.

[12] Francisco Hernández, *Rerum Medicarum Novae Hispaniae Thesaurus seu Plantarum*. Rome, 1649. Liber III, Cap. XLVII, p. 81.

[13] J. J. Valentini, *Mexican Paper*. American Antiquarian Society. October 1880. p. 68.

[14] Paul C. Standley, *Trees and shrubs of Mexico*. U. S. National Museum, Washington, 1920. Vol. 23, part 2.

[15] Paul C. Standley, *The Mexican and Central American species of Ficus*. Washington, 1917. pp. 10, 20.

[16] Francisci Hernandi, *Medici Atque Historici*. Madrid, 1790. pp. 165–176.

A Good Paper is Made from Metl

[1] Motolinía (de Benavente T.), *Historia de los Índios de Nueva España*. (*XVI century*). Barcelona, 1914. Tome III, cap. XIV.

[2] Lopez de Gómara, *Historia de México*. Antwerp, 1554. p. 344.

[3] Francisci Hernandi, *op. cit.* p. 270. *Metl plantae quam Mexicanansi Maquei appellant* . . . Tota enim illa, lignorum sepiendorumque: agrorum, usum, praestet. Caules lignorum folia vero tecta tengendi, imbricum, lancium, *papyri filique*. . . .

[4] "El Papel indiano se componía de la pencas del *Maguéy,* que en lengua Nacional se llama *Métl,* y en Castellano *Pita.* Las echaban á podrir, y lavaban el hilo de ellas, el que haviendose ablandado estendian, para componer su papel gruesso, ó delgado, que despues bruñian para pintar en él. Tambien hacien papel de las hojas de Palma, y Yo tengo algunos de estos delgados, y blandos tanto como la seda." *Catalogo del Museo Historico Indiano del Caballero Lorenzo Boturini Benaduci.* Madrid, 1746. pp. 95–96.

[5] William Prescott, *The Conquest of Mexico.* New York, 1843. p. 75; note p. 76.

[6] Francesco Clavigero, *The History of Mexico.* London, 1787. Book VII, p. 407.

[7] Papel en que escribían. Metl, se hacía de las Pencas de el Maguei, ó Pita, que llaman en España: las echaban á podrir en Agua, lababan el hilo de ellas, ablandado le estendían para componer su Papel gruesso, que despues bruñían para pintar en él. Papel de Palma blando, y blanco como de seda, que le he visto; cogían las ojas de Palma, las molían, y batían, y bruñían. Hernán Cortés, *Historia de Nueva-España.* Edited by Lorenzana. Mexico, 1770.

[8] Hans Lenz, *op. cit.*

[9] Alexander von Humboldt, *Researches concerning the Institutions and Monuments,* etc. London, 1814. p. 137.

[10] Alexander von Humboldt, *op. cit.* p. 189.

[11] Alexander von Humboldt, *op. cit.* pp. 135–6.

[12] Alexander von Humboldt, *op. cit.* pp. 135–6.

[13] William Prescott, *op. cit.* pp. 48–9 and notes.

[14] García Icazbalceta, "De estas pencas . . . y encima de estas pencas hacen un papel de algodon engrudado tan delgado como una muy delgada toca; y sobre aquel papel y encima de la penca labran todos sus dibujos; y es de los principales instrumentos de su oficio." *Colección de Documentos,* etc. Mexico, 1858. Vol. I, p. 245.

[15] Lucien Biart, *The Aztecs.* Chicago, 1887. pp. 315–16. After stating his opinion about the substances from which paper was made he continues: "Unfortunately, we do not know to what process the Aztecs had recourse, although this industry was in full activity a long time after the Conquest . . . paper three feet wide, fifteen to twenty feet long, which was rolled up like ancient papyrus or folded like the leaves of a screen."

[16] a) Valentini concluded in an otherwise well-developed historical study that the Mayas made their paper from the rubber tree, *Castilloa elastica,* and that the Aztecs made

theirs from the leaves of the maguey. *Mexican Paper.* American Antiquarian Society. October 1881.

b) Starr, that two types of paper were made by the Mexicans, *"Maguey* paper" in the plateau, bark paper among the Mayas. *Mexican Paper.* American Antiquities. 1900.

c) Brinton says "skins," *Maya Chronicles.* 1882. p. 65.

d) Thomas, studying the Troano Codex, says "Agave paper."

e) Seler insists on the paper of the Maya being "Agavepapier." *Gesammelte Abhandlungen zur Amerikanischen Sprach- und Alterthumskunde.* Berlin, 1902–03.

f) Thompson, "Deerhide and Agave, henequen paper." Letter to the author, March 16, 1931.

g) Morley, "Fiber paper or upon skins covered with sizing of white lime." *Ruins of Quirigua.* Washington, 1935. p. 204.

h) Gann, "Agave fiber." *History of the Mayas.* New York, 1931.

i) Spinden, *"Amatl* paper . . . prepared deerskin and bark." *Ancient civilization of Mexico.* New York, 1922. p. 116.

j) Gates, "Paper of two kinds . . . from the fig tree and from the *te-amoxtli,* the papyrus reed." *The de la Cruz-Badiano Aztec Herbal.* Baltimore, 1939. p. 122.

k) Vaillant, "Paper was beaten from the bark of the *amate* or wild fig tree." *op. cit.* p. 195.

The Paper Clue of the Sumus

[1] Edward Conzemius, *Ethnographical Survey of the Miskito and Sumu Indians of Honduras and Nicaragua.* Washington Bulletin 106. 1938. p. 48.

[2] Dard Hunter, *Primitive Papermaking.* Chillicothe, 1927.

[3] Frederick Starr, *Mexican Paper.* American Antiquities. 1900.

[4] Francisco Hernández, *op. cit.*

[5] Edward Conzemius, *op. cit.*

[6] V. Wolfgang von Hagen, *The Jicaque (Jorrupan) Indians of Honduras.* New York, 1943. pp. 30, 34, 40, 68.

[7] Sayce, R., *Primitive arts and crafts.* Cambridge, England, 1933.

[8] Joyce Torday, *Les Bushongs*. As quoted by Sayce.

[9] Nicolás León, *La Industria del papel en Mexico, en los Tiempos precolombinos y Actuales*. Boletin del Museo Nacional. Mexico, 1924. Tome 11, 4, nr. 5.

The Otomi Papermakers

[1] Frederick Starr, *Notes upon the Ethnology of Southern Mexico*. Proceedings Dav. Academy of Science. IX, 1904.

[2] Nicolás León, *op. cit.*

[3] Hans Lenz, *op. cit.*

[4] Bodil Christensen, *Los Otomis*. Revista Mexicana de Estudios Antropologicos. 1942. Vol. VI, 1.

[5] Francisco Hernández, *Historia de las Plantas de Nueva España*. Mexico, 1942. p. 257.

The Fibers of the Amatl

[1] Rudolph Schwede, *Ueber das Papier der Maya Codices*. Dresden, 1912. pp. 13–17.

[2] Rudolph Schwede, *op. cit.* p. 17.

[3] Francisci Hernandi, *Thesaurus, op. cit.* Mexican edition of 1942. p. 254, in which *Amatzauhtli* or paper glue is described. This is an orchid Epidendrum pastoris. Found extensively in the regions of Tepoztlan.

[4] Pietro Martire, *op. cit.*

[5] Letter to the author from Dr. Robert Redfield, dated October 19, 1942.

[6] Diego de Landa, *op. cit.*

[7] Rudolph Schwede, *Ein weiterer Beitrag zur Geschichte des altamerikanischen Papiers*. Jahresbericht der Vereinigung fur angewandte Botanik, XIII. 1916.

[8] J. J. Valentini, *op. cit.*

[9] Frederick Starr, *op. cit.*

NOTES

The Geography of Paper Tribute

[1] *Codex Mendoza.* Translated and edited by James Cooper Clark. 3 vls. London, 1938.

[2] Paul C. Standley, *op. cit.* p. 28.

[3] V. Wolfgang von Hagen, *op. cit.* p. 40.

[4] Thomas Francis Carter, *The Invention of Printing in China.* New York, 1931.

[5] Robert Redfield, *Tepoztlan.* Chicago, 1930.

[6] *Ficus cotinifolia* H. B. K. "Large tree, gray bark . . . leaf blades oblong, oval, obovate oval, rounded oblong . . . 5–13 cm long . . . rounded at the base." Standley, *The American Species of Fig.* p. 19.

[7] Edward King Kingsborough, *op. cit.* Vol. I, p. 60; plates 23, 26, 27.

[8] Francisci Hernandi, *Medici Atque Historici.* Madrid, 1790. p. 172. "De ytzamatl, seu papyro novaculari. Arbor est vastae magnitudinis, ita vocata, quod Amaquahuitl, ex qua paratur." (Concerning the *itzamatl* or dagger papyrus. It is a tree of vast proportions, so called because it is similar to the *amaquahuitl,* from which papyrus is made, but its leaves have the shape of daggers.)

[9] A variety of *itzamatl* (*amate prieto*). Both plants are reduced to synonymity under *Ficus cotinifolia.*

[10] Francisci Hernandi, *op. cit.* Vol. I, p. 167. Amazquitl, seu unedone papyracea. Folia fert Limonis, sed magnis acuminata Comata est et umbrae tantum gratia expedita. Ad genera Ytzamatl videtur . . .

[11] Sigvald Linné, *Zapotecan Antiquities.* Stockholm, 1938. pp. 20–21.

[12] Juan López de Velasco, *Geografia y descripción universal de las Indias* etc. Madrid, 1894. p. 197.

[13] *Letters.* Translated by J. B. Morris. London, 1928. p. 94.

[14] Bernal Díaz del Castillo, *op. cit.* Spanish edition. Mexico, 1904. Vol. II, p. 144.

[15] Frederico Gomez de Orozco, *Quien fue el Autor Material del Codice Mendocino y Quien su Interprete?* Revista Mexicana de Estudios Historicos. Mexico, 1941. Tome I, 1.

See also: Codex Mendoza. Edited by James Cooper Clark. London, 1938.

The Paper-World of the Aztecs

[1] Dard Hunter, *Chinese ceremonial paper*. Chillicothe, 1937.

[2] J. J. Valentini, *op. cit.*

[3] George Vaillant, *op. cit.* p. 224.

[4] Bernardino de Sahagún, *Historia General de las Cosas de Nueva España*. Madrid, 1905. Vol. V. *Also: Codex Florentino* used as illustrations for Sahagún's History.

[5] Bernardino de Sahagún, *op. cit.* Translated by Fanny Bandelier. Nashville, 1932.

[6] Bernardino de Sahagún, *op. cit.* Translated by Fanny Bandelier. Nashville, 1932. The pages from which these extracts on the use of *amatl*-paper were taken are as follows: 41, 45, 61, 64, 66, 67, 68, 69, 73, 81, 85, 86, 87, 88, 93, 95, 96, 108, 109, 110, 118, 120, 121, 122, 124, 125, 126, 127, 129, 131, 136, 140, 141, 159, 160, 191, 192.

[7] William Prescott, *op. cit.*

Bibliography

Alamán, D. Lucas, *Disertaciones sobre la historia de la República Megicana*. Mégico, 1844.

Aragon, Javier O., *Expansión territorial del Imperio Méxicano*. Anales del Museo Nacional. Mexico, 1935.

Bandelier, A. F., *On the art and mode of warfare of the ancient Mexicans*. Peabody Museum. Cambridge, 1877.

Bandelier, A. F., *On the social organization and mode of government of the ancient Mexicans*. Peabody Museum. Cambridge, 1879.

Biart, Lucien, *The Aztecs*. Chicago, 1887.

Biblioteca Mexicana, *Crónica Mexicana escrita por D. H. Tezozomoc*. Mexico, 1878.

Blom, Frans, *The Conquest of Yucatan*. New York, 1936.

Blum, André, *On the origin of paper*. Translated by H. M. Lydenberg. New York, 1934.

Boturini-Benaduci, Lorenzo. *Catalogo del Museo Historico Indiano*. Madrid, 1746.

Casas, Bartolomé de las, *Historia de las Indias*. Madrid, 1875.

Carter, Thomas Francis, *The Invention of printing in China*. New York, 1931.

Ceballos Novelo, R. J., *Las instituciones Aztecas*. Mexico, 1937.

Clavigero, Francesco, *The history of Mexico*. London, 1787.

Cogolludo, Fray F. L. de, *Historia de Yucatan*. Madrid, 1688.

Cortés, Hernando, *Letters of Cortés*. Translated and edited by F. A. MacNutt. New York and London, 1908.

Cortés, Hernando, *Historia de Nueva-España*. Edited by Lorenzana. Mexico, 1770.

Díaz del Castillo, Bernal, *The true history of the conquest of Mexico*. New York, 1927.

Gann, Thomas, *History of the Maya*. New York, 1931.

García Cubas, A., *Atlas Geográfico y Estadístico de los Estadas Unidos de Mexico*. Mexico, 1927.

Gates, William, *The de la Cruz-Badiano Aztec Herbal*. Baltimore, 1939.

Gilberti, Maturion, *Arte de la lengua tarasca ó de Michoacán*. Mexico, 1898.

Gómara, Francisco Lopez de, *Historia de México*. Antwerp, 1554.

Haring, C. H., *Trade and navigation between Spain and the Indies*. Cambridge, 1918.

Hernández, Francisco, *Rerum medicarum novae Hispaniae thesaurus seu plantarum*. Rome, 1649.

Hernández, Francisco, *Historia de las plantas de Nueva España*. Mexico, 1942.

Hernandi, Francisci, *Medici atque historici*. Madrid, 1790.

Humboldt, Alexander von, *Vues des Cordillères et monuments des peuples indigènes de l'Amérique*. Paris, 1816.

Humboldt, Alexander von, *Researches concerning the institutions and monuments of the ancient inhabitants of America*. London, 1814.

Hunter, Dard, *Chinese ceremonial paper*. Chillicothe, 1937.

Hunter, Dard, *Old papermaking*. Chillicothe, 1923.

Hunter, Dard, *Old papermaking in China and Japan*. Chillicothe, 1932.

Hunter, Dard, *Papermaking through eighteen centuries*. New York, 1930.

Hunter, Dard, *Primitive papermaking*. Chillicothe, 1927.

Karabacek, Josef v., *Das arabische Papier*. Vienna, 1887.

Kingsborough, Edward, Lord, *Antiquities of Mexico*. London, 1830–1848.

Landa, Diego de, *Rélation des choses de Yucatan*. Paris, 1864.

Lenz, Hans, *La industria papelera en Mexico*. Mexico, 1940.

Linné, Sigvald, *Zapotecan antiquities*. Stockholm, 1938.

BIBLIOGRAPHY

MADARIAGA, SALVADOR DE, *Christopher Columbus*. New York, 1940.

MADARIAGA, SALVADOR DE, *Hernán Cortés*. New York, 1941.

MARTIRE, PIETRO D'ANGHIERE, *De rebus oceanicis*. Coloniae, 1574.

MARTYR, PETRUS, *De orbe novo*. Paris, 1587.

MEANS, PHILIP AINSWORTH, *History of the Spanish conquest of Yucatan and of the Itzas*. Cambridge, 1917.

MOLINA, ALONSO DE, *Vocabulario en lengua castellana y mexicana*. Mexico, 1571.

MORENO, M. M., *La organización política y social de los Aztecas*. Mexico, 1931.

MOTOLINÍA, TORIBIO (DE BENAVENTE), *Historia de los Indios de la Nueva España*. XVI century. Barcelona, 1914.

MUMFORD, LEWIS, *Technics and civilization*. New York, 1934.

MUÑOZ CAMARGO, DIEGO, *Historia de Tlaxcala*. XVI century. Mexico, 1904.

PEÑAFIEL, ANTONIO, *Nombres geográficos de México*. Mexico, 1885.

PEÑAFIEL, ANTONIO, *Nomenclatura geográfica de México*. Mexico, 1897.

PLANCARTE Y NAVARRETE, FRANCISCO, *La sierra de Tepoztlan*. 1580.

PONCE, ALONSO, *Relación breve y verdadera de Algunas cosas*. Madrid, 1842.

PRESCOTT, WILLIAM, *History of the conquest of Mexico*. New York, 1843.

REDFIELD, ROBERT, *Tepoztlan*. Chicago, 1930.

ROBELO, CECILIO A., *Diccionario de aztequismos*. Mexico, 1912.

SAHAGÚN, BERNARDINO DE, *Codex Florentino*: Illustrations for: *Historia general de las cosas de Nueva España*. Madrid, 1905.

SAHAGÚN, BERNARDINO DE, *A history of ancient Mexico*. Translation by Fanny Bandelier. Nashville, 1932.

SANDOVAL, PRUDENCIO DE, *Historia de la vida y hechos del emperador Carlos V*. Pamplona, 1614.

SAYCE, R., *Primitive arts and crafts*. Cambridge, England, 1933.

SCHWEDE, RUDOLPH, *Ueber das Papier der Maya Codices*. Dresden, 1912.

SPINDEN, H. J., *Ancient civilizations of Mexico and central America*. New York, 1922.

SPINDEN, H. J., *Indian manuscripts of southern Mexico*. Washington, 1933.

STANDLEY, PAUL C., *The Mexican and Central American species of Ficus*. Washington, 1917.

STANDLEY, PAUL C., *Trees and shrubs of Mexico*. Washington, 1920.

THOMPSON, J. ERIC, *Mexico before Cortes*. New York, 1933.

URBINA, MANUEL, *Los amates de Hernández*. Mexico, 1903.

VAILLANT, GEORGE C., *The Aztecs of Mexico*. New York, 1941.

VELASCO, JUAN LÓPEZ DE, *Geografía y descripción universal de las Indias*. Madrid, 1894.

VILLAGUTIERRE Y SOTOMAYOR, JUAN, *Historia de la conquista de la provincia de el Itza*. Madrid, 1701.

VON HAGEN, VICTOR WOLFGANG, *The Jicaque (Jorrupan) Indians of Honduras*. New York, 1943.

VON HAGEN, VICTOR WOLFGANG, *Jungle in the clouds*. New York, 1940.

VON HAGEN, VICTOR WOLFGANG, *Mexican Papermaking plants*. Journal of the New York Botanical Garden, vol. 44, 1943.

Specific References to Papyrus

THEOPHRASTUS
Inquiry into Plants. Loeb Classical Library. 2V.
(First accurate description.)

HERODOTUS
Loeb Classical Library. 4V

CASSIODORUS
Varr XI

PLINY
Natural History Vol. XIII. Lib. II.

ENCYCLOPEDIA BRITANNICA, 11th ed. "Papyrus."

BIBLIOGRAPHY

Specific References to Poly-Micronesian Bark-cloth

Hose & McDougall, *Pagan Tribes of Borneo,* Vol. I.

Martin, John, *Natives of Tonga Islands,* 1817.

Brigham, W. T., *Ka Hana Kapa, the Papermaking of Bark-cloth in Hawaii.* Honolulu. 1911.

Raven, H. C., Bark-cloth Making in the Central Celebes. *Natural History Magazine.* Vol. XXXIII. 1932.

Index

INDEX

Illustrations

PLATE I

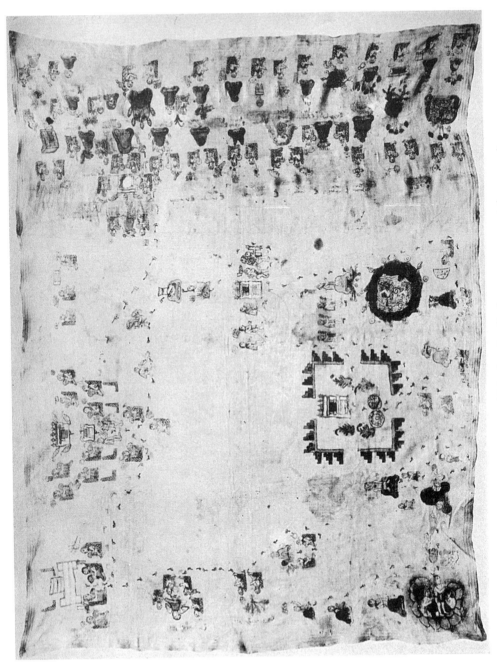

Aztec Codex, *Valley of Mexico*. On finely woven cotton (about 1500).
Since these drawings were executed on cloth, they are known as *lienzos*.

PLATE 2

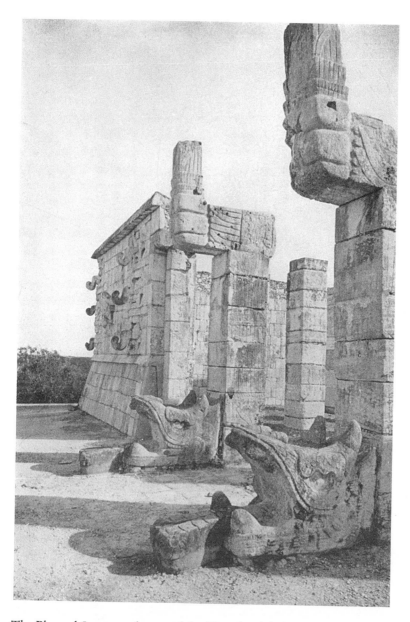

The Plumed Serpent columns of the Temple of the Warriors in *Chichen Itzá.*

The cult of Quetzalcoatl (symbolized by these totems at the temple entrance) was active in revitalizing much of Mayadom from the eighth century on. The open jaws of the snake, converted into Quetzal feathers, became the most powerful symbol of all. During this period of Mayan history, written documents were first folded into book form and the art of writing made notable progress.

Photograph: Fred L. Black

PLATE 3

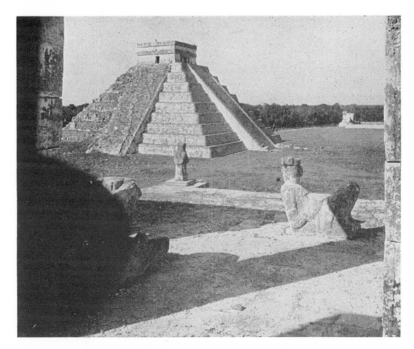

(a) El Castillo, the temple erected in honor of Kukulkan (Mayan name for white-skinned, bearded Quetzalcoatl).

Chichen Itzá bore the brunt of non-Mayan influence, that of the Toltec of the Central Mexican plateau, everywhere associated with the Plumed Serpent totem.

Photograph: Fred L. Black

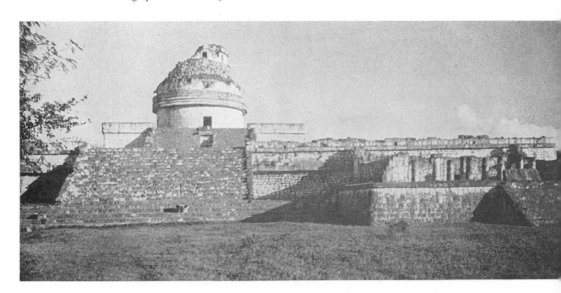

(b) Famous *El Caracol,* so-called observatory in *Chichen Itzá.*

Whether actually used as an observatory is unknown, but its shape greatly resembles that of a modern planetarium. Though lacking instruments, the Mayas were accomplished astronomers, able to name the stars and planets and use celestial movements as a guide.

Photograph: Fred L. Black

PLATE 4

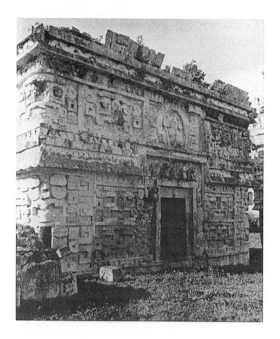

(a) Nunnery at *Uxmal*.

Mayan "books" and hieroglyphic rolls were probably housed within these flamboyantly carved exteriors. *Uxmal*, part of a constellation of ruins including *Kabah* and *Labna*, lies 150 miles east of *Chichen Itzá*.

Photograph: Fred L. Black

(b) A Sacred Serpent stylization on wall of Nunnery at *Uxmal*.

Photograph: Fred L. Black

PLATE 5

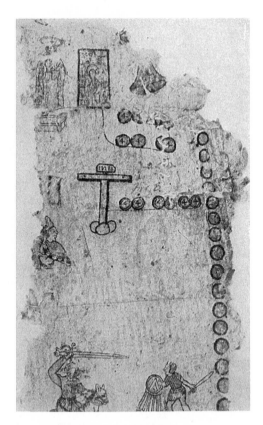

(*a*) Codex Telapalco, *Valley of Mexico.*
On *amatl* paper (about 1530).

Much Christian symbolism is incorporated into
this Aztec drawing of the Spanish Conquest.

Museum of the American Indian, Heye Foundation, New York

(*b*) Post-Conquest Aztec document after the Aztec language
was reduced to phonetic writing by the Spaniards. On *amatl*
paper (about 1590).

Museum of the American Indian, Heye Foundation, New York

PLATE 6

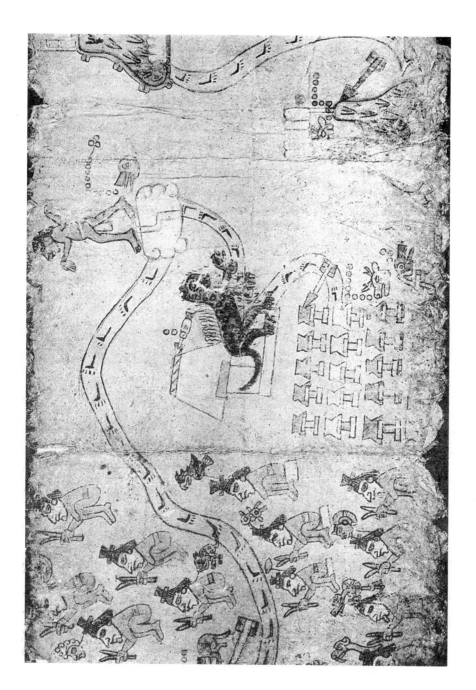

Codex Fernández Leal. Aztec, on *amatl* paper (about 1500).
In the Bancroft Library, University of California

PLATE 7

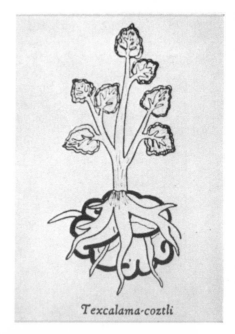

Texcalama-coztli

(a) Amacoztic as drawn by an Aztec herbalist.

The only known Aztec drawing of the "paper tree." Heavy lines encircling the roots represent rocks *(tescal)*.

From the de la Cruz-Badiano, Aztec Herbal, 1552.

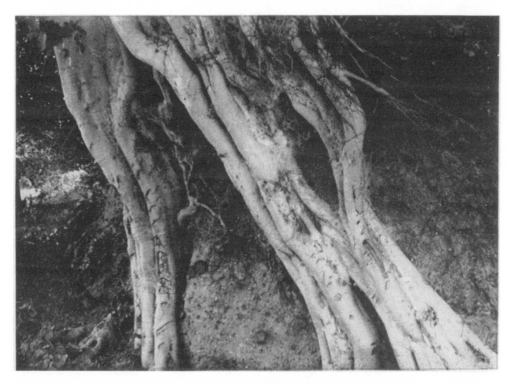

(b) Amacoztic, or *tescalamatl* (tree-of-the-rocks), one of the common Aztec "paper trees."

The *amatl amarillo* of modern Mexico *(Ficus petiolaris)* called tree-of-the-rocks because of its manner of growth.

PLATE 8

*(a) Itzamatl (amate prieto)
(Ficus tecolutensis).*

(b) Iztacamatl (amate blanco),
the white-barked wild fig*(Ficus
cotinifolia).*

PLATE 9

(a) Amazquitl, the "paper tree" *(Ficus padifolia).*

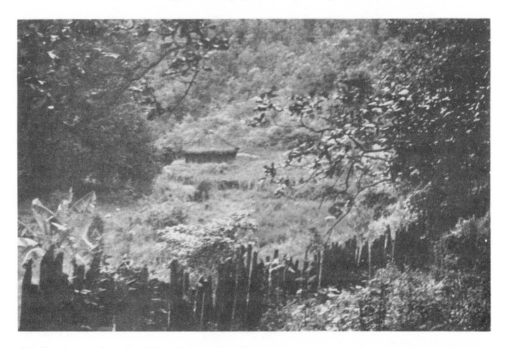

(b) Jicaque Indian dwellings behind a tall wooden palisade in the Department of *Yoro, Honduras.*

PLATE 10

(a) Jicaque men, one of whom wears a bark-cloth tunic.

(b) Jicaque man in bark-cloth tunic using blow-gun.

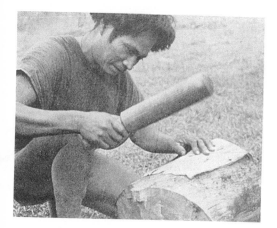

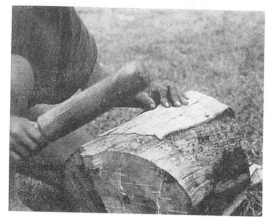

(c & d) Stripped from the tree, the bark is first washed and then beaten until transformed into a soft, thin piece of bark-paper.

PLATE 11

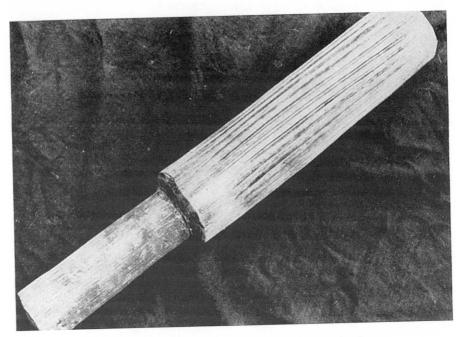

(*a*) Bark-beater. The Azetc used a similar beater made of stone.

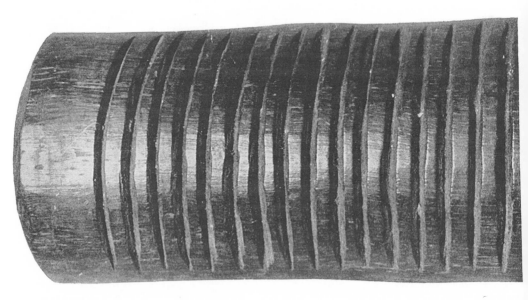

(*b*) Bark-beater made from hard inner core of a palm.
Used by the Miskito Indians of *Honduras* in preparing their bark-cloth from the inner bark of the *Ficus* tree.
Beater's incised lines follow usual pattern of all primitive bark-beaters everywhere.

PLATE 12

(a) A piece of bark-cloth from *Java* showing effects from a similar beater to 11a.

(b) Author's specimen of bark-cloth from the *Mosquito Coast*.
Beater has left same ribbing and corduroy effect (as 11a and b).

PLATE 13

Photograph of paper sample made by modern
Otomi Indians of *San Pablito,* in *Pahuatlan,
Hidalgo.*

Sheet 12 x 14 made from *Ficus* fibres; white paper made
from *amate amarillo* of the *Ficus petiolaris.*

Collected by Dr. Dard Hunter

PLATE 14

(*a*) Photograph of bark-cloth paper from *Java,
Tegalsari*, near *Ponorogo, Madioen*.
First state of bark-paper from mulberry tree *(Broussonetia
papyrifera)*. Photograph taken through light.

(*b*) Same specimen as 14a.
Second state; note ribbing left by beater.

PLATE 15

(a) Third state of specimen 14a.

Surface photograph; compare with Otomi specimen (13).

(b) Bark-cloth from *West Coast of Africa.*

Taken through light to show matting of fibres; made from mulberry tree *(Broussonetia papyrifera).*

Collected by Dr. Dard Hunter

PLATE 16

(a) Same as specimen 15b. Surface lighting.

(b) First state of bark-paper specimen from *Java*.
Taken through strong light to show matting effects of *Moraceae*
species. Fibres from mulberry tree *(Broussonetia papyrifera)*.
Collected by Dr. Dard Hunter

PLATE 17

(a) Second state of specimen 16b.
Beaten with lighter and smoother beater; note the effect on fibres.
Taken through strong light.

(b) Same as specimen 17a.
Surface lighting; compare with Otomi specimen (13).

PLATE 18

(a) Final state of specimen 16b.
Beaten with still finer beater. Lighting behind specimen.

(b) Final state of bark-cloth (16b). Surface lighting.

PLATE 19

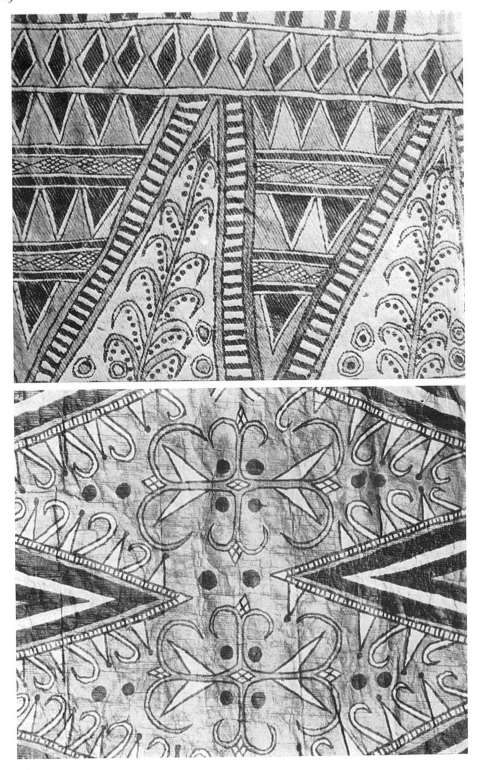

(a & b) Tapa cloth.
Fabricated in precisely the same manner as Aztec *amatl* paper; decorated with elaborate designs.
Collected in the *Celebes, Toare, Boda District, Central Celebes.* *Originals in the U. S. Nat. Museum*

PLATE 20

(a) Fruit of the *Tecomaxochiamatl (Ficus involuta)*.
This edible fig is closely related to the common variety of the *Ficus Carica.*
Photograph: Bodil Christensen

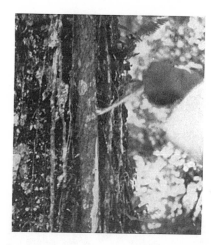

(b) Detail of trunk of *Tecomaxochiamatl (Ficus involuta)*.
The Indian is stripping an aerial root growing on side of main trunk. Next
step in preparing this bark for paper is washing it free of *leche de palo*—the
white sap of the *Ficus.*
Photograph: Bodil Christensen

PLATE 21

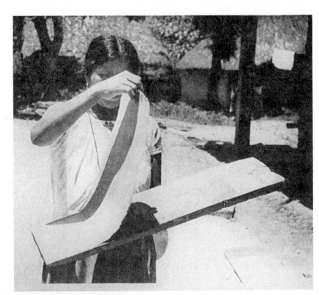

(a) "Peeling" a sheet of paper from the board.

The paper is taken off as soon as all the moisture has been evaporated by the sun. The side of the paper lying close to the board is smooth; the other, which has been the operative surface, is rough.

Photograph: Bodil Christensen

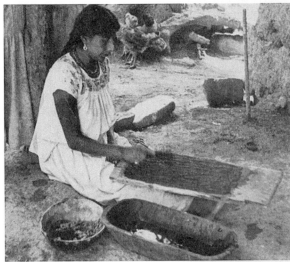

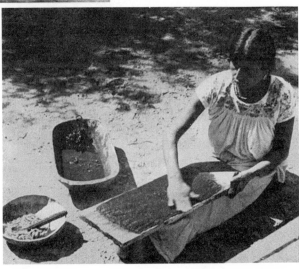

(b & c) Various steps in papermaking.

Far in advance of the process of bark-cloth beating, this Mexican method of forming a sheet of paper by felting small fibre strips marks a unique development in primitive papermaking. The result closely approximates "real" paper.

Photograph: Bodil Christensen

PLATE 22

Sample of *Xalamatl-limon* paper.
From inner fibres of the tree *Ficus padifolia*.
Made by the *Otomi* Indians, San Pablito, Hidalgo, Mexico.

PLATE 23

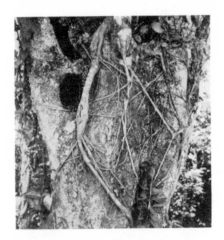

(a) Aerial roots and the enveloping buttress roots of the strangler fig, *Ficus padifolia* HBK.

The Indians take their fibres from these exposed aerial roots. (The dead, crushed, and rotted "Host plant" may be seen obscured by the enveloping *Ficus*.)

Photograph: Bodil Christensen

(b) Leaves of *Ficus padifolia,* the *Cilamatl tree of the Aztecs*.

Birds eagerly eat the small clusters of figs produced in the dry season, thus aiding the propagation of new trees.

Photograph: Bodil Christensen

PLATE 24

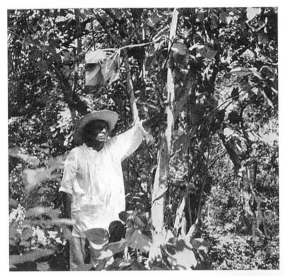

(*a*) The *Teotzitzicaxtle* (in Spanish, *chichicaste*) belongs to the *Moraceae*, the great and varied mulberry family.

Although classed as a "woody shrub," it grows to a height of 13 to 16 feet. As most other members of the mulberry family, the plant is rich in white viscous *leche;* the bast fibres are delicate and long.

Photograph: Bodil Christensen

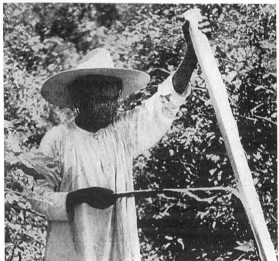

(*b*) A step in obtaining fibres from the *Teotzitzicaxtle*.

An Aztec Indian peels fibres from a cut branch. This is the men's work; the rest of papermaking is the task of women.

Photograph: Bodil Christensen

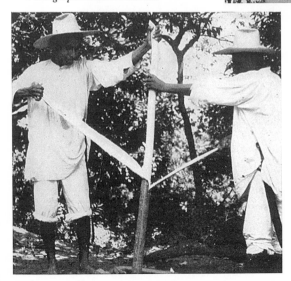

(*c*) Stripping the fine, delicate bast fibres from the *Teotzitzicaxtle*.

Photograph: Bodil Christensen

PLATE 25

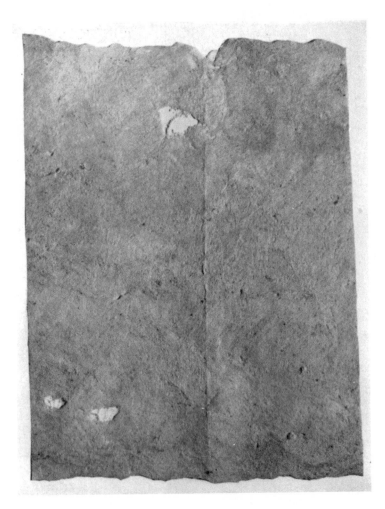

Sample of *Chichicaste*-paper.
Made by the *Otomi Indians,* San Pablito, Hidalgo, Mexico.

PLATE 26

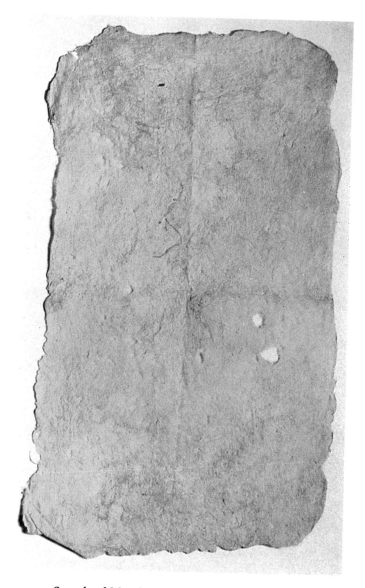

Sample of *Moral*-paper.
From the inner bark of the *Mulberry* tree (*Morus species*).
Made by the *Otomi* Indians, San Pablito, Hidalgo. Mexico.

PLATE 27

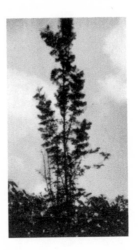

(a) The Bull's Horn Acacia of Mexico (*Acacia cornigera* [L] Willd.).

One of the large plants belonging to the *Mimosaceae*, it usually grows to a height of 35-40 feet on the open hot plains.

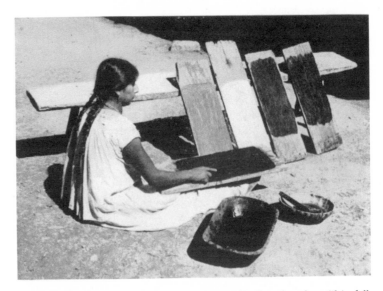

(b) Aztec papermaker of *Chicontepec* displays her four "kinds" of paper.

The papermaking "instruments" are a *batea* for holding disintegrated fibres, a board for fashioning the paper, and a burnt cob. Here on the board, paper being made from fibres of the *Huitzamaxalli (Acacia cornigera* [L] Willd.); in the background, left to right, papers made from *Teotzitzicaxtle (Urera baccifera* [L] Gaud.), *Cilamatl (Ficus padifolia* HBK), *Tecomaxochiamatl (Ficus involuta* [Liebm.] miquel), and again *Huitzamaxalli.*

PLATE 28

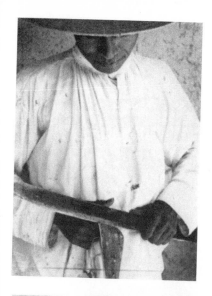

(a) Fibre preparation.
After stripping the bark from the tree, a machete is used to cut the fibre from the bark (in this series a, b, and c, bast fibres of the *Cilamatl*).

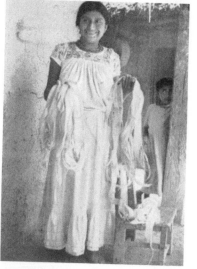

(b) After washing the fibres, the papermaker then boils them in limewater so that they disintegrate and become pliable for felting.

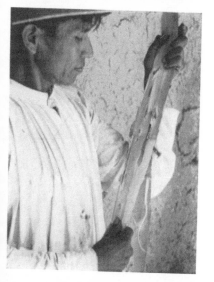

(c) Loosened from the outer bark, the fibre is now entirely divested of the soft white bast fibres of the "inner bark."

PLATE 29

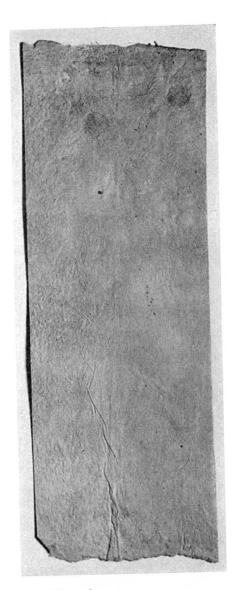

Sample of *Cilamatl*-paper.
From the fibres of *Ficus padifolia*.
Made by the *Aztec* Indians of Chicontepec, Vera Cruz, Mexico.

PLATE 30

(*a*) Fibres of the *Agave* (century plant) from which paper was *believed* to have been made.
These are revealed to be woody, devoid of latex-tubes, hard, and unable to be extended by beating. Enlarged *48x*.

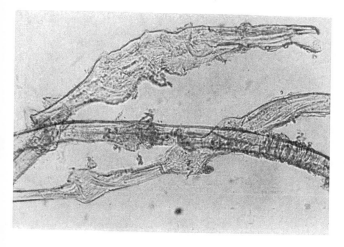

(*b*) Fibres from a 16th century Aztec Codex.
Soft bast fibres and across them a latex-tube, indicated by the string-like binding of the tube. Enlarged *98x*.
In the Bancroft Library, University of California

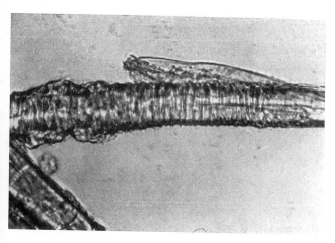

(*c*) Latex-tube from a 16th century Aztec Codex.
The tube is tell-tale evidence of the *Moraceae* origin of the fibres. Enlarged *108x*.
In the Peabody Museum

PLATE 31

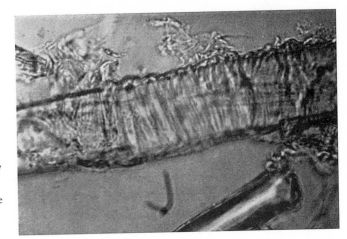

(a) Fibres from a 16th century Aztec Codex.

These reveal typical *Moraceae* latex-tube through which white sap flows.

In the Bancroft Library

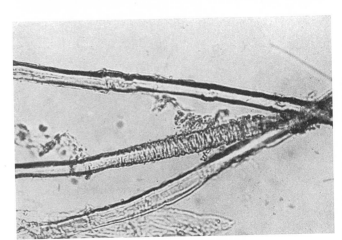

(b) Fibres for a piece of modern Otomi paper.

Soft non-wooded bast fibres and collapsed latex-tubes would indicate that this modern Otomi paper and the old Aztec paper were made from the same plant—bast fibres of the wild fig. Enlarged *85x.*

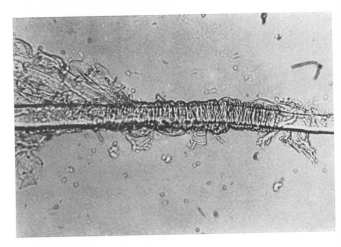

(c) Fibres from Aztec manuscripts.

Another microphotograph showing all the characteristics of bast fibres of the *Moraceae* family.

PLATE 32

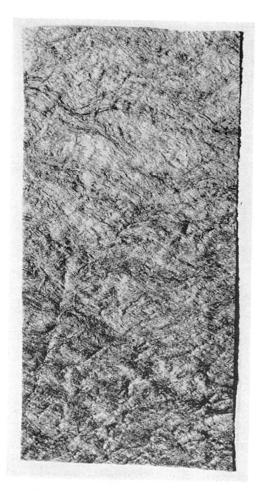

Sample of *bark-cloth*.
From the fibres of the *Ficus* tree.
Made by the *Miskito* people, Honduras.

PLATE 33

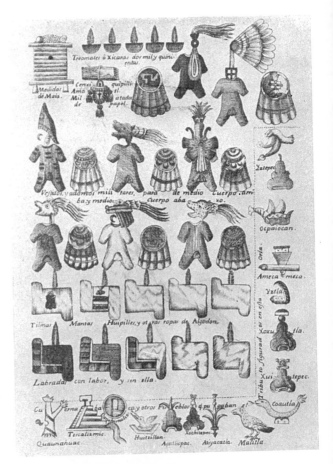

(a) Page from Lorenzana's *Historia de Nueva España*, Mexico, 1770.

A list of tributes to the Aztecs from the neighbors they had conquered. The item of paper is in the upper left-hand corner, immediately to the right and below the bin of corn-tribute.

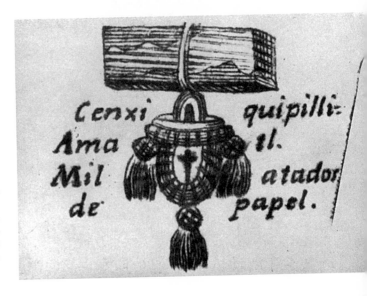

(b) Detail of Illustration 33a.

This is the symbol for paper from *Quauhnahuac* (or *Cuernavaca* in the modern Mexican State of *Morelos*), which yielded 8,000 reams or bundles of paper. Part Aztec, part Spanish, the quotation reads: *Cenxiquipilli amatl* (8,000 bundles of paper), *mil atados de papel* (1,000 bundles of paper).

PLATE 34

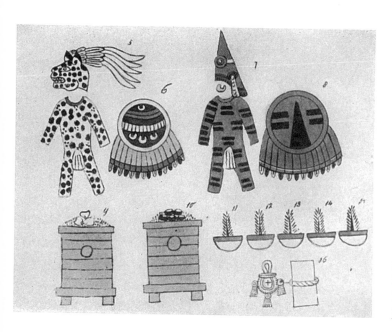

(a) Reproductions from Montezuma's *Book of Tributes* from the Codex Mendocina.

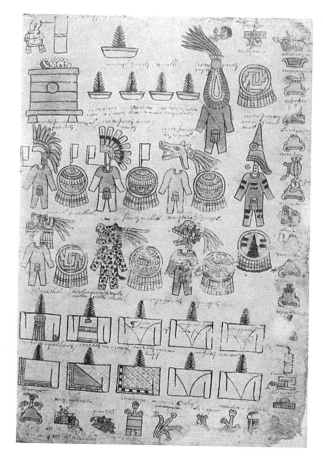

(b) Page from *Libro de los Tributos.*

Delineations of the articles of tribute, paper, feather helmets, shields, blankets; on the margin, heraldic devices of villages yielding tribute. A roll of *amatl* paper faintly outlined in extreme upper left-hand corner; attached to it, the pouch-symbol of eight thousand. "Eight thousand rolls of *amatl* paper shall be brought to *Tenochtitlan*."

In the Museo Nacional

PLATE 35

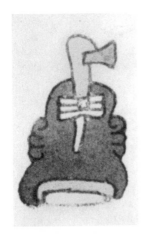

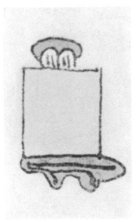

(*a*) Heraldic symbol of *Tepoztlan*.

(*b*) Heraldic symbol of *Amacoztitlaan*, the town of the yellow paper.

(*c*) Heraldic symbol of *Itzamatitlan*, the village of the "dagger paper."

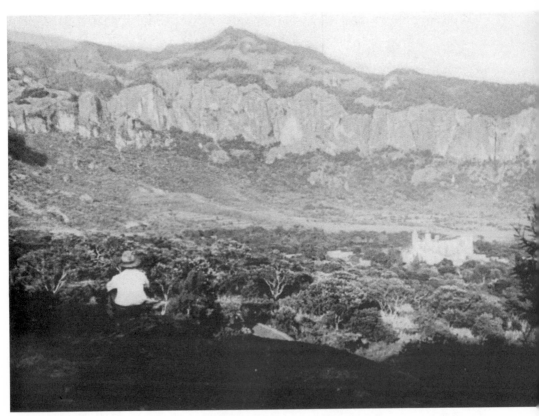

(*d*) *Tepoztlan*, valley of the *Tlahuica*-speaking peoples—and of the papermakers.

PLATE 36

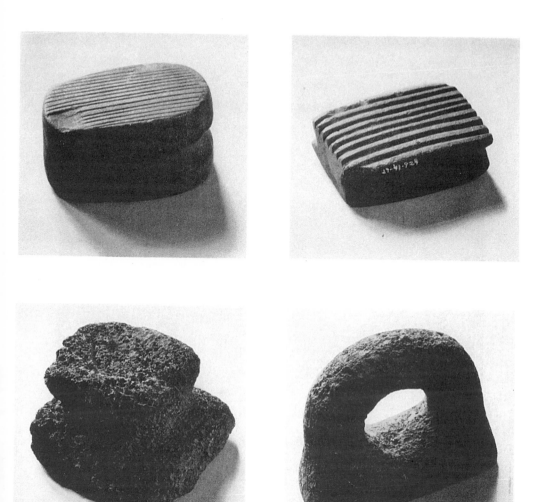

(a, b, c, d) Bark-beaters from the *Valley of Teotihuacan.*
Most common artifact in the *Valley of Mexico* is stone bark-beater and *planche* fashioned for the sole purpose of manufacturing *amatl* paper from the inner bast fibres of the wild fig tree.
From the collections of the University Museum, University of Pennsylvania

PLATE 37

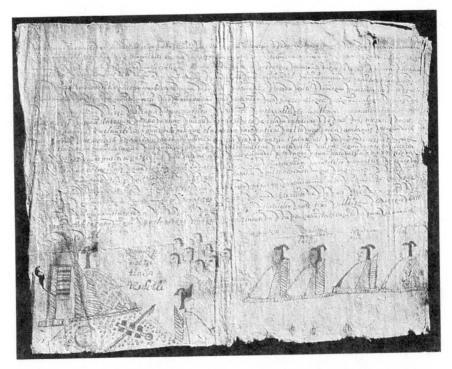

Anonymous Aztec manuscript (about 1550). On *amatl* paper made from a species of *Ficus*.

Written in Latin characters, this chronicle of the Aztec Empire contains three double leaves (each approximately 12 x 7 inches) describing the Aztec migration and reigns of Aztec "emperors" from Itzcoatl to Quauhtemozin. (See *Manuscripts in the Dept. of Middle American Research, No. 5, 1933*).

PLATE 38

(a) Mayan clay stamps.

Used for decorative stamping of ceramics and weavings; also for "printing" on *huun* paper. (See *Stamping, a Mass Production Printing Method 2,000 Years Old*, by Maurice Ries. Middle American Research Series, No. 4.) *Photograph: Dept. of Middle American Research.*

(b) Mayan flat clay stamps compared with a modern piece of movable type.

Their extensive use of the clay stamp shows that the Mayans and Aztecs already envisioned the same labor-saving devices as the movable type-face. The obvious evolution from the clay stamp would be: clay stamp, wood stamp, metal stamp; decorative stamps, cartouches, permanent hieroglyphic stamps. *Clay stamps and paper!* These were the cultural elements which met premature oblivion at the hands of the Spanish conquerors.

PLATE 39

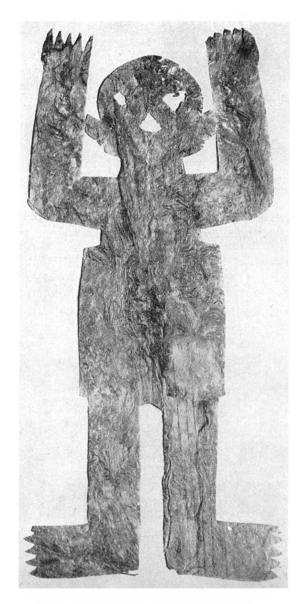

Paper doll made of *Xalamatl*-paper (dark).
Used in witchcraft by the *Otomi* and *Aztec* Indians.
This is the sole use to which *Xalamatl*-paper is put today.

A CATALOG OF SELECTED
DOVER BOOKS
IN ALL FIELDS OF INTEREST

A CATALOG OF SELECTED DOVER
BOOKS IN ALL FIELDS OF INTEREST

CONCERNING THE SPIRITUAL IN ART, Wassily Kandinsky. Pioneering work by father of abstract art. Thoughts on color theory, nature of art. Analysis of earlier masters. 12 illustrations. 80pp. of text. 5⅜ x 8½. 23411-8 Pa. $4.95

ANIMALS: 1,419 Copyright-Free Illustrations of Mammals, Birds, Fish, Insects, etc., Jim Harter (ed.). Clear wood engravings present, in extremely lifelike poses, over 1,000 species of animals. One of the most extensive pictorial sourcebooks of its kind. Captions. Index. 284pp. 9 x 12. 23766-4 Pa. $14.95

CELTIC ART: The Methods of Construction, George Bain. Simple geometric techniques for making Celtic interlacements, spirals, Kells-type initials, animals, humans, etc. Over 500 illustrations. 160pp. 9 x 12. (USO) 22923-8 Pa. $9.95

AN ATLAS OF ANATOMY FOR ARTISTS, Fritz Schider. Most thorough reference work on art anatomy in the world. Hundreds of illustrations, including selections from works by Vesalius, Leonardo, Goya, Ingres, Michelangelo, others. 593 illustrations. 192pp. 7⅛ x 10¼. 20241-0 Pa. $9.95

CELTIC HAND STROKE-BY-STROKE (Irish Half-Uncial from "The Book of Kells"): An Arthur Baker Calligraphy Manual, Arthur Baker. Complete guide to creating each letter of the alphabet in distinctive Celtic manner. Covers hand position, strokes, pens, inks, paper, more. Illustrated. 48pp. 8¼ x 11. 24336-2 Pa. $3.95

EASY ORIGAMI, John Montroll. Charming collection of 32 projects (hat, cup, pelican, piano, swan, many more) specially designed for the novice origami hobbyist. Clearly illustrated easy-to-follow instructions insure that even beginning papercrafters will achieve successful results. 48pp. 8¼ x 11. 27298-2 Pa. $3.50

THE COMPLETE BOOK OF BIRDHOUSE CONSTRUCTION FOR WOODWORKERS, Scott D. Campbell. Detailed instructions, illustrations, tables. Also data on bird habitat and instinct patterns. Bibliography. 3 tables. 63 illustrations in 15 figures. 48pp. 5¼ x 8½. 24407-5 Pa. $2.50

BLOOMINGDALE'S ILLUSTRATED 1886 CATALOG: Fashions, Dry Goods and Housewares, Bloomingdale Brothers. Famed merchants' extremely rare catalog depicting about 1,700 products: clothing, housewares, firearms, dry goods, jewelry, more. Invaluable for dating, identifying vintage items. Also, copyright-free graphics for artists, designers. Co-published with Henry Ford Museum & Greenfield Village. 160pp. 8¼ x 11. 25780-0 Pa. $10.95

HISTORIC COSTUME IN PICTURES, Braun & Schneider. Over 1,450 costumed figures in clearly detailed engravings–from dawn of civilization to end of 19th century. Captions. Many folk costumes. 256pp. 8⅜ x 11¾. 23150-X Pa. $12.95

STICKLEY CRAFTSMAN FURNITURE CATALOGS, Gustav Stickley and L. & J. G. Stickley. Beautiful, functional furniture in two authentic catalogs from 1910. 594 illustrations, including 277 photos, show settles, rockers, armchairs, reclining chairs, bookcases, desks, tables. 183pp. 6½ x 9¼. 23838-5 Pa. $11.95

AMERICAN LOCOMOTIVES IN HISTORIC PHOTOGRAPHS: 1858 to 1949, Ron Ziel (ed.). A rare collection of 126 meticulously detailed official photographs, called "builder portraits," of American locomotives that majestically chronicle the rise of steam locomotive power in America. Introduction. Detailed captions. xi + 129pp. 9 x 12. 27393-8 Pa. $12.95

AMERICA'S LIGHTHOUSES: An Illustrated History, Francis Ross Holland, Jr. Delightfully written, profusely illustrated fact-filled survey of over 200 American lighthouses since 1716. History, anecdotes, technological advances, more. 240pp. 8 x 10¾. 25576-X Pa. $12.95

TOWARDS A NEW ARCHITECTURE, Le Corbusier. Pioneering manifesto by founder of "International School." Technical and aesthetic theories, views of industry, economics, relation of form to function, "mass-production split" and much more. Profusely illustrated. 320pp. 6⅛ x 9¼. (USO) 25023-7 Pa. $9.95

HOW THE OTHER HALF LIVES, Jacob Riis. Famous journalistic record, exposing poverty and degradation of New York slums around 1900, by major social reformer. 100 striking and influential photographs. 233pp. 10 x 7⅞. 22012-5 Pa. $11.95

FRUIT KEY AND TWIG KEY TO TREES AND SHRUBS, William M. Harlow. One of the handiest and most widely used identification aids. Fruit key covers 120 deciduous and evergreen species; twig key 160 deciduous species. Easily used. Over 300 photographs. 126pp. 5⅜ x 8½. 20511-8 Pa. $3.95

COMMON BIRD SONGS, Dr. Donald J. Borror. Songs of 60 most common U.S. birds: robins, sparrows, cardinals, bluejays, finches, more—arranged in order of increasing complexity. Up to 9 variations of songs of each species. Cassette and manual 99911-4 $8.95

ORCHIDS AS HOUSE PLANTS, Rebecca Tyson Northen. Grow cattleyas and many other kinds of orchids—in a window, in a case, or under artificial light. 63 illustrations. 148pp. 5⅜ x 8½. 23261-1 Pa. $4.95

MONSTER MAZES, Dave Phillips. Masterful mazes at four levels of difficulty. Avoid deadly perils and evil creatures to find magical treasures. Solutions for all 32 exciting illustrated puzzles. 48pp. 8¼ x 11. 26005-4 Pa. $2.95

MOZART'S DON GIOVANNI (DOVER OPERA LIBRETTO SERIES), Wolfgang Amadeus Mozart. Introduced and translated by Ellen H. Bleiler. Standard Italian libretto, with complete English translation. Convenient and thoroughly portable—an ideal companion for reading along with a recording or the performance itself. Introduction. List of characters. Plot summary. 121pp. 5¼ x 8½. 24944-1 Pa. $3.95

TECHNICAL MANUAL AND DICTIONARY OF CLASSICAL BALLET, Gail Grant. Defines, explains, comments on steps, movements, poses and concepts. 15-page pictorial section. Basic book for student, viewer. 127pp. 5⅜ x 8½. 21843-0 Pa. $4.95

BRASS INSTRUMENTS: Their History and Development, Anthony Baines. Authoritative, updated survey of the evolution of trumpets, trombones, bugles, cornets, French horns, tubas and other brass wind instruments. Over 140 illustrations and 48 music examples. Corrected and updated by author. New preface. Bibliography. 320pp. 5⅜ x 8½. 27574-4 Pa. $9.95

HOLLYWOOD GLAMOR PORTRAITS, John Kobal (ed.). 145 photos from 1926-49. Harlow, Gable, Bogart, Bacall; 94 stars in all. Full background on photographers, technical aspects. 160pp. 8⅞ x 11¼. 23352-9 Pa. $12.95

MAX AND MORITZ, Wilhelm Busch. Great humor classic in both German and English. Also 10 other works: "Cat and Mouse," "Plisch and Plumm," etc. 216pp. 5⅜ x 8½. 20181-3 Pa. $6.95

THE RAVEN AND OTHER FAVORITE POEMS, Edgar Allan Poe. Over 40 of the author's most memorable poems: "The Bells," "Ulalume," "Israfel," "To Helen," "The Conqueror Worm," "Eldorado," "Annabel Lee," many more. Alphabetic lists of titles and first lines. 64pp. 5⁵⁄₁₆ x 8¼. 26685-0 Pa. $1.00

PERSONAL MEMOIRS OF U. S. GRANT, Ulysses Simpson Grant. Intelligent, deeply moving firsthand account of Civil War campaigns, considered by many the finest military memoirs ever written. Includes letters, historic photographs, maps and more. 528pp. 6⅛ x 9¼. 28587-1 Pa. $12.95

AMULETS AND SUPERSTITIONS, E. A. Wallis Budge. Comprehensive discourse on origin, powers of amulets in many ancient cultures: Arab, Persian Babylonian, Assyrian, Egyptian, Gnostic, Hebrew, Phoenician, Syriac, etc. Covers cross, swastika, crucifix, seals, rings, stones, etc. 584pp. 5⅜ x 8½. 23573-4 Pa. $12.95

RUSSIAN STORIES/PYCCKNE PACCKA3bI: A Dual-Language Book, edited by Gleb Struve. Twelve tales by such masters as Chekhov, Tolstoy, Dostoevsky, Pushkin, others. Excellent word-for-word English translations on facing pages, plus teaching and study aids, Russian/English vocabulary, biographical/critical introductions, more. 416pp. 5⅜ x 8½. 26244-8 Pa. $9.95

PHILADELPHIA THEN AND NOW: 60 Sites Photographed in the Past and Present, Kenneth Finkel and Susan Oyama. Rare photographs of City Hall, Logan Square, Independence Hall, Betsy Ross House, other landmarks juxtaposed with contemporary views. Captures changing face of historic city. Introduction. Captions. 128pp. 8¼ x 11. 25790-8 Pa. $9.95

AIA ARCHITECTURAL GUIDE TO NASSAU AND SUFFOLK COUNTIES, LONG ISLAND, The American Institute of Architects, Long Island Chapter, and the Society for the Preservation of Long Island Antiquities. Comprehensive, well-researched and generously illustrated volume brings to life over three centuries of Long Island's great architectural heritage. More than 240 photographs with authoritative, extensively detailed captions. 176pp. 8¼ x 11. 26946-9 Pa. $14.95

NORTH AMERICAN INDIAN LIFE: Customs and Traditions of 23 Tribes, Elsie Clews Parsons (ed.). 27 fictionalized essays by noted anthropologists examine religion, customs, government, additional facets of life among the Winnebago, Crow, Zuni, Eskimo, other tribes. 480pp. 6⅛ x 9¼. 27377-6 Pa. $10.95

FRANK LLOYD WRIGHT'S HOLLYHOCK HOUSE, Donald Hoffmann. Lavishly illustrated, carefully documented study of one of Wright's most controversial residential designs. Over 120 photographs, floor plans, elevations, etc. Detailed perceptive text by noted Wright scholar. Index. 128pp. 9¼ x 10¾. 27133-1 Pa. $11.95

THE MALE AND FEMALE FIGURE IN MOTION: 60 Classic Photographic Sequences, Eadweard Muybridge. 60 true-action photographs of men and women walking, running, climbing, bending, turning, etc., reproduced from rare 19th-century masterpiece. vi + 121pp. 9 x 12. 24745-7 Pa. $10.95

1001 QUESTIONS ANSWERED ABOUT THE SEASHORE, N. J. Berrill and Jacquelyn Berrill. Queries answered about dolphins, sea snails, sponges, starfish, fishes, shore birds, many others. Covers appearance, breeding, growth, feeding, much more. 305pp. 5¼ x 8¼. 23366-9 Pa. $8.95

GUIDE TO OWL WATCHING IN NORTH AMERICA, Donald S. Heintzelman. Superb guide offers complete data and descriptions of 19 species: barn owl, screech owl, snowy owl, many more. Expert coverage of owl-watching equipment, conservation, migrations and invasions, etc. Guide to observing sites. 84 illustrations. xiii + 193pp. 5⅜ x 8½. 27344-X Pa. $8.95

MEDICINAL AND OTHER USES OF NORTH AMERICAN PLANTS: A Historical Survey with Special Reference to the Eastern Indian Tribes, Charlotte Erichsen-Brown. Chronological historical citations document 500 years of usage of plants, trees, shrubs native to eastern Canada, northeastern U.S. Also complete identifying information. 343 illustrations. 544pp. 6½ x 9¼. 25951-X Pa. $12.95

STORYBOOK MAZES, Dave Phillips. 23 stories and mazes on two-page spreads: Wizard of Oz, Treasure Island, Robin Hood, etc. Solutions. 64pp. 8¼ x 11. 23628-5 Pa. $2.95

NEGRO FOLK MUSIC, U.S.A., Harold Courlander. Noted folklorist's scholarly yet readable analysis of rich and varied musical tradition. Includes authentic versions of over 40 folk songs. Valuable bibliography and discography. xi + 324pp. 5⅜ x 8½. 27350-4 Pa. $9.95

MOVIE-STAR PORTRAITS OF THE FORTIES, John Kobal (ed.). 163 glamor, studio photos of 106 stars of the 1940s: Rita Hayworth, Ava Gardner, Marlon Brando, Clark Gable, many more. 176pp. 8⅞ x 11¼. 23546-7 Pa. $12.95

BENCHLEY LOST AND FOUND, Robert Benchley. Finest humor from early 30s, about pet peeves, child psychologists, post office and others. Mostly unavailable elsewhere. 73 illustrations by Peter Arno and others. 183pp. 5⅜ x 8½. 22410-4 Pa. $6.95

YEKL and THE IMPORTED BRIDEGROOM AND OTHER STORIES OF YIDDISH NEW YORK, Abraham Cahan. Film Hester Street based on Yekl (1896). Novel, other stories among first about Jewish immigrants on N.Y.'s East Side. 240pp. 5⅜ x 8½. 22427-9 Pa. $6.95

SELECTED POEMS, Walt Whitman. Generous sampling from *Leaves of Grass*. Twenty-four poems include "I Hear America Singing," "Song of the Open Road," "I Sing the Body Electric," "When Lilacs Last in the Dooryard Bloom'd," "O Captain! My Captain!"—all reprinted from an authoritative edition. Lists of titles and first lines. 128pp. 5¹⁵⁄₁₆ x 8¼. 26878-0 Pa. $1.00

THE BEST TALES OF HOFFMANN, E. T. A. Hoffmann. 10 of Hoffmann's most important stories: "Nutcracker and the King of Mice," "The Golden Flowerpot," etc. 458pp. 5⅜ x 8½. 21793-0 Pa. $9.95

FROM FETISH TO GOD IN ANCIENT EGYPT, E. A. Wallis Budge. Rich detailed survey of Egyptian conception of "God" and gods, magic, cult of animals, Osiris, more. Also, superb English translations of hymns and legends. 240 illustrations. 545pp. 5⅜ x 8½. 25803-3 Pa. $13.95

FRENCH STORIES/CONTES FRANÇAIS: A Dual-Language Book, Wallace Fowlie. Ten stories by French masters, Voltaire to Camus: "Micromegas" by Voltaire; "The Atheist's Mass" by Balzac; "Minuet" by de Maupassant; "The Guest" by Camus, six more. Excellent English translations on facing pages. Also French-English vocabulary list, exercises, more. 352pp. 5⅜ x 8½. 26443-2 Pa. $9.95

CHICAGO AT THE TURN OF THE CENTURY IN PHOTOGRAPHS: 122 Historic Views from the Collections of the Chicago Historical Society, Larry A. Viskochil. Rare large-format prints offer detailed views of City Hall, State Street, the Loop, Hull House, Union Station, many other landmarks, circa 1904-1913. Introduction. Captions. Maps. 144pp. 9⅜ x 12¼. 24656-6 Pa. $12.95

OLD BROOKLYN IN EARLY PHOTOGRAPHS, 1865-1929, William Lee Younger. Luna Park, Gravesend race track, construction of Grand Army Plaza, moving of Hotel Brighton, etc. 157 previously unpublished photographs. 165pp. 8⅞ x 11¾.
 23587-4 Pa. $13.95

THE MYTHS OF THE NORTH AMERICAN INDIANS, Lewis Spence. Rich anthology of the myths and legends of the Algonquins, Iroquois, Pawnees and Sioux, prefaced by an extensive historical and ethnological commentary. 36 illustrations. 480pp. 5⅜ x 8½. 25967-6 Pa. $10.95

AN ENCYCLOPEDIA OF BATTLES: Accounts of Over 1,560 Battles from 1479 B.C. to the Present, David Eggenberger. Essential details of every major battle in recorded history from the first battle of Megiddo in 1479 B.C. to Grenada in 1984. List of Battle Maps. New Appendix covering the years 1967-1984. Index. 99 illustrations. 544pp. 6½ x 9¼. 24913-1 Pa. $16.95

SAILING ALONE AROUND THE WORLD, Captain Joshua Slocum. First man to sail around the world, alone, in small boat. One of great feats of seamanship told in delightful manner. 67 illustrations. 294pp. 5⅜ x 8½. 20326-3 Pa. $6.95

ANARCHISM AND OTHER ESSAYS, Emma Goldman. Powerful, penetrating, prophetic essays on direct action, role of minorities, prison reform, puritan hypocrisy, violence, etc. 271pp. 5⅜ x 8½. 22484-8 Pa. $7.95

MYTHS OF THE HINDUS AND BUDDHISTS, Ananda K. Coomaraswamy and Sister Nivedita. Great stories of the epics; deeds of Krishna, Shiva, taken from puranas, Vedas, folk tales; etc. 32 illustrations. 400pp. 5⅜ x 8½. 21759-0 Pa. $12.95

BEYOND PSYCHOLOGY, Otto Rank. Fear of death, desire of immortality, nature of sexuality, social organization, creativity, according to Rankian system. 291pp. 5⅜ x 8½.
 20485-5 Pa. $8.95

A THEOLOGICO-POLITICAL TREATISE, Benedict Spinoza. Also contains unfinished Political Treatise. Great classic on religious liberty, theory of government on common consent. R. Elwes translation. Total of 421pp. 5⅜ x 8½. 20249-6 Pa. $9.95

MY BONDAGE AND MY FREEDOM, Frederick Douglass. Born a slave, Douglass became outspoken force in antislavery movement. The best of Douglass' autobiographies. Graphic description of slave life. 464pp. 5⅜ x 8½. 22457-0 Pa. $8.95

FOLLOWING THE EQUATOR: A Journey Around the World, Mark Twain. Fascinating humorous account of 1897 voyage to Hawaii, Australia, India, New Zealand, etc. Ironic, bemused reports on peoples, customs, climate, flora and fauna, politics, much more. 197 illustrations. 720pp. 5⅜ x 8½. 26113-1 Pa. $15.95

THE PEOPLE CALLED SHAKERS, Edward D. Andrews. Definitive study of Shakers: origins, beliefs, practices, dances, social organization, furniture and crafts, etc. 33 illustrations. 351pp. 5⅜ x 8½. 21081-2 Pa. $8.95

THE MYTHS OF GREECE AND ROME, H. A. Guerber. A classic of mythology, generously illustrated, long prized for its simple, graphic, accurate retelling of the principal myths of Greece and Rome, and for its commentary on their origins and significance. With 64 illustrations by Michelangelo, Raphael, Titian, Rubens, Canova, Bernini and others. 480pp. 5⅜ x 8½. 27584-1 Pa. $9.95

PSYCHOLOGY OF MUSIC, Carl E. Seashore. Classic work discusses music as a medium from psychological viewpoint. Clear treatment of physical acoustics, auditory apparatus, sound perception, development of musical skills, nature of musical feeling, host of other topics. 88 figures. 408pp. 5⅜ x 8½. 21851-1 Pa. $10.95

THE PHILOSOPHY OF HISTORY, Georg W. Hegel. Great classic of Western thought develops concept that history is not chance but rational process, the evolution of freedom. 457pp. 5⅜ x 8½. 20112-0 Pa. $9.95

THE BOOK OF TEA, Kakuzo Okakura. Minor classic of the Orient: entertaining, charming explanation, interpretation of traditional Japanese culture in terms of tea ceremony. 94pp. 5⅜ x 8½. 20070-1 Pa. $3.95

LIFE IN ANCIENT EGYPT, Adolf Erman. Fullest, most thorough, detailed older account with much not in more recent books, domestic life, religion, magic, medicine, commerce, much more. Many illustrations reproduce tomb paintings, carvings, hieroglyphs, etc. 597pp. 5⅜ x 8½. 22632-8 Pa. $12.95

SUNDIALS, Their Theory and Construction, Albert Waugh. Far and away the best, most thorough coverage of ideas, mathematics concerned, types, construction, adjusting anywhere. Simple, nontechnical treatment allows even children to build several of these dials. Over 100 illustrations. 230pp. 5⅜ x 8½. 22947-5 Pa. $8.95

DYNAMICS OF FLUIDS IN POROUS MEDIA, Jacob Bear. For advanced students of ground water hydrology, soil mechanics and physics, drainage and irrigation engineering, and more. 335 illustrations. Exercises, with answers. 784pp. 6⅛ x 9¼.
65675-6 Pa. $19.95

SONGS OF EXPERIENCE: Facsimile Reproduction with 26 Plates in Full Color, William Blake. 26 full-color plates from a rare 1826 edition. Includes "The Tyger," "London," "Holy Thursday," and other poems. Printed text of poems. 48pp. 5¼ x 7.
24636-1 Pa. $4.95

OLD-TIME VIGNETTES IN FULL COLOR, Carol Belanger Grafton (ed.). Over 390 charming, often sentimental illustrations, selected from archives of Victorian graphics—pretty women posing, children playing, food, flowers, kittens and puppies, smiling cherubs, birds and butterflies, much more. All copyright-free. 48pp. 9¼ x 12¼.
27269-9 Pa. $7.95

PERSPECTIVE FOR ARTISTS, Rex Vicat Cole. Depth, perspective of sky and sea, shadows, much more, not usually covered. 391 diagrams, 81 reproductions of drawings and paintings. 279pp. 5⅜ x 8½. 22487-2 Pa. $7.95

DRAWING THE LIVING FIGURE, Joseph Sheppard. Innovative approach to artistic anatomy focuses on specifics of surface anatomy, rather than muscles and bones. Over 170 drawings of live models in front, back and side views, and in widely varying poses. Accompanying diagrams. 177 illustrations. Introduction. Index. 144pp. 8⅜ x11¼. 26723-7 Pa. $8.95

GOTHIC AND OLD ENGLISH ALPHABETS: 100 Complete Fonts, Dan X. Solo. Add power, elegance to posters, signs, other graphics with 100 stunning copyright-free alphabets: Blackstone, Dolbey, Germania, 97 more—including many lower-case, numerals, punctuation marks. 104pp. 8⅛ x 11. 24695-7 Pa. $8.95

HOW TO DO BEADWORK, Mary White. Fundamental book on craft from simple projects to five-bead chains and woven works. 106 illustrations. 142pp. 5⅜ x 8. 20697-1 Pa. $4.95

THE BOOK OF WOOD CARVING, Charles Marshall Sayers. Finest book for beginners discusses fundamentals and offers 34 designs. "Absolutely first rate . . . well thought out and well executed."—E. J. Tangerman. 118pp. 7¾ x 10⅝. 23654-4 Pa. $6.95

ILLUSTRATED CATALOG OF CIVIL WAR MILITARY GOODS: Union Army Weapons, Insignia, Uniform Accessories, and Other Equipment, Schuyler, Hartley, and Graham. Rare, profusely illustrated 1846 catalog includes Union Army uniform and dress regulations, arms and ammunition, coats, insignia, flags, swords, rifles, etc. 226 illustrations. 160pp. 9 x 12. 24939-5 Pa. $10.95

WOMEN'S FASHIONS OF THE EARLY 1900s: An Unabridged Republication of "New York Fashions, 1909," National Cloak & Suit Co. Rare catalog of mail-order fashions documents women's and children's clothing styles shortly after the turn of the century. Captions offer full descriptions, prices. Invaluable resource for fashion, costume historians. Approximately 725 illustrations. 128pp. 8⅜ x 11¼. 27276-1 Pa. $11.95

THE 1912 AND 1915 GUSTAV STICKLEY FURNITURE CATALOGS, Gustav Stickley. With over 200 detailed illustrations and descriptions, these two catalogs are essential reading and reference materials and identification guides for Stickley furniture. Captions cite materials, dimensions and prices. 112pp. 6½ x 9¼. 26676-1 Pa. $9.95

EARLY AMERICAN LOCOMOTIVES, John H. White, Jr. Finest locomotive engravings from early 19th century: historical (1804–74), main-line (after 1870), special, foreign, etc. 147 plates. 142pp. 11⅜ x 8¼. 22772-3 Pa. $10.95

THE TALL SHIPS OF TODAY IN PHOTOGRAPHS, Frank O. Braynard. Lavishly illustrated tribute to nearly 100 majestic contemporary sailing vessels: Amerigo Vespucci, Clearwater, Constitution, Eagle, Mayflower, Sea Cloud, Victory, many more. Authoritative captions provide statistics, background on each ship. 190 black-and-white photographs and illustrations. Introduction. 128pp. 8⅞ x 11¼. 27163-3 Pa. $14.95

EARLY NINETEENTH-CENTURY CRAFTS AND TRADES, Peter Stockham (ed.). Extremely rare 1807 volume describes to youngsters the crafts and trades of the day: brickmaker, weaver, dressmaker, bookbinder, ropemaker, saddler, many more. Quaint prose, charming illustrations for each craft. 20 black-and-white line illustrations. 192pp. 4⅝ x 6. 27293-1 Pa. $4.95

VICTORIAN FASHIONS AND COSTUMES FROM HARPER'S BAZAR, 1867–1898, Stella Blum (ed.). Day costumes, evening wear, sports clothes, shoes, hats, other accessories in over 1,000 detailed engravings. 320pp. 9⅜ x 12¼.
22990-4 Pa. $15.95

GUSTAV STICKLEY, THE CRAFTSMAN, Mary Ann Smith. Superb study surveys broad scope of Stickley's achievement, especially in architecture. Design philosophy, rise and fall of the Craftsman empire, descriptions and floor plans for many Craftsman houses, more. 86 black-and-white halftones. 31 line illustrations. Introduction 208pp. 6½ x 9¼. 27210-9 Pa. $9.95

THE LONG ISLAND RAIL ROAD IN EARLY PHOTOGRAPHS, Ron Ziel. Over 220 rare photos, informative text document origin (1844) and development of rail service on Long Island. Vintage views of early trains, locomotives, stations, passengers, crews, much more. Captions. 8⅜ x 11¾. 26301-0 Pa. $13.95

THE BOOK OF OLD SHIPS: From Egyptian Galleys to Clipper Ships, Henry B. Culver. Superb, authoritative history of sailing vessels, with 80 magnificent line illustrations. Galley, bark, caravel, longship, whaler, many more. Detailed, informative text on each vessel by noted naval historian. Introduction. 256pp. 5⅜ x 8½.
27332-6 Pa. $7.95

TEN BOOKS ON ARCHITECTURE, Vitruvius. The most important book ever written on architecture. Early Roman aesthetics, technology, classical orders, site selection, all other aspects. Morgan translation. 331pp. 5⅜ x 8½. 20645-9 Pa. $8.95

THE HUMAN FIGURE IN MOTION, Eadweard Muybridge. More than 4,500 stopped-action photos, in action series, showing undraped men, women, children jumping, lying down, throwing, sitting, wrestling, carrying, etc. 390pp. 7⅞ x 10⅝.
20204-6 Clothbd. $27.95

TREES OF THE EASTERN AND CENTRAL UNITED STATES AND CANADA, William M. Harlow. Best one-volume guide to 140 trees. Full descriptions, woodlore, range, etc. Over 600 illustrations. Handy size. 288pp. 4½ x 6⅜.
20395-6 Pa. $6.95

SONGS OF WESTERN BIRDS, Dr. Donald J. Borror. Complete song and call repertoire of 60 western species, including flycatchers, juncoes, cactus wrens, many more–includes fully illustrated booklet. Cassette and manual 99913-0 $8.95

GROWING AND USING HERBS AND SPICES, Milo Miloradovich. Versatile handbook provides all the information needed for cultivation and use of all the herbs and spices available in North America. 4 illustrations. Index. Glossary. 236pp. 5⅜ x 8½.
25058-X Pa. $6.95

BIG BOOK OF MAZES AND LABYRINTHS, Walter Shepherd. 50 mazes and labyrinths in all–classical, solid, ripple, and more–in one great volume. Perfect inexpensive puzzler for clever youngsters. Full solutions. 112pp. 8¼ x 11.
22951-3 Pa. $4.95

PIANO TUNING, J. Cree Fischer. Clearest, best book for beginner, amateur. Simple repairs, raising dropped notes, tuning by easy method of flattened fifths. No previous skills needed. 4 illustrations. 201pp. 5⅜ x 8½. 23267-0 Pa. $6.95

A SOURCE BOOK IN THEATRICAL HISTORY, A. M. Nagler. Contemporary observers on acting, directing, make-up, costuming, stage props, machinery, scene design, from Ancient Greece to Chekhov. 611pp. 5⅜ x 8½. 20515-0 Pa. $12.95

THE COMPLETE NONSENSE OF EDWARD LEAR, Edward Lear. All nonsense limericks, zany alphabets, Owl and Pussycat, songs, nonsense botany, etc., illustrated by Lear. Total of 320pp. 5⅜ x 8½. (USO) 20167-8 Pa. $7.95

VICTORIAN PARLOUR POETRY: An Annotated Anthology, Michael R. Turner. 117 gems by Longfellow, Tennyson, Browning, many lesser-known poets. "The Village Blacksmith," "Curfew Must Not Ring Tonight," "Only a Baby Small," dozens more, often difficult to find elsewhere. Index of poets, titles, first lines. xxiii + 325pp. 5⅜ x 8¼. 27044-0 Pa. $8.95

DUBLINERS, James Joyce. Fifteen stories offer vivid, tightly focused observations of the lives of Dublin's poorer classes. At least one, "The Dead," is considered a masterpiece. Reprinted complete and unabridged from standard edition. 160pp. 5³⁄₁₆ x 8¼. 26870-5 Pa. $1.00

THE HAUNTED MONASTERY and THE CHINESE MAZE MURDERS, Robert van Gulik. Two full novels by van Gulik, set in 7th-century China, continue adventures of Judge Dee and his companions. An evil Taoist monastery, seemingly supernatural events; overgrown topiary maze hides strange crimes. 27 illustrations. 328pp. 5⅜ x 8½. 23502-5 Pa. $8.95

THE BOOK OF THE SACRED MAGIC OF ABRAMELIN THE MAGE, translated by S. MacGregor Mathers. Medieval manuscript of ceremonial magic. Basic document in Aleister Crowley, Golden Dawn groups. 268pp. 5⅜ x 8½. 23211-5 Pa. $9.05

NEW RUSSIAN-ENGLISH AND ENGLISH-RUSSIAN DICTIONARY, M. A. O'Brien. This is a remarkably handy Russian dictionary, containing a surprising amount of information, including over 70,000 entries. 366pp. 4½ x 6¼. 20208-9 Pa. $9.95

HISTORIC HOMES OF THE AMERICAN PRESIDENTS, Second, Revised Edition, Irvin Haas. A traveler's guide to American Presidential homes, most open to the public, depicting and describing homes occupied by every American President from George Washington to George Bush. With visiting hours, admission charges, travel routes. 175 photographs. Index. 160pp. 8¼ x 11. 26751-2 Pa. $11.95

NEW YORK IN THE FORTIES, Andreas Feininger. 162 brilliant photographs by the well-known photographer, formerly with *Life* magazine. Commuters, shoppers, Times Square at night, much else from city at its peak. Captions by John von Hartz. 181pp. 9¼ x 10¾. 23585-8 Pa. $12.95

INDIAN SIGN LANGUAGE, William Tomkins. Over 525 signs developed by Sioux and other tribes. Written instructions and diagrams. Also 290 pictographs. 111pp. 6⅛ x 9¼. 22029-X Pa. $3.95

ANATOMY: A Complete Guide for Artists, Joseph Sheppard. A master of figure drawing shows artists how to render human anatomy convincingly. Over 460 illustrations. 224pp. 8⅜ x 11¼. 27279-6 Pa. $11.95

MEDIEVAL CALLIGRAPHY: Its History and Technique, Marc Drogin. Spirited history, comprehensive instruction manual covers 13 styles (ca. 4th century thru 15th). Excellent photographs; directions for duplicating medieval techniques with modern tools. 224pp. 8⅜ x 11¼. 26142-5 Pa. $12.95

DRIED FLOWERS: How to Prepare Them, Sarah Whitlock and Martha Rankin. Complete instructions on how to use silica gel, meal and borax, perlite aggregate, sand and borax, glycerine and water to create attractive permanent flower arrangements. 12 illustrations. 32pp. 5⅜ x 8½. 21802-3 Pa. $1.00

EASY-TO-MAKE BIRD FEEDERS FOR WOODWORKERS, Scott D. Campbell. Detailed, simple-to-use guide for designing, constructing, caring for and using feeders. Text, illustrations for 12 classic and contemporary designs. 96pp. 5⅜ x 8½. 25847-5 Pa. $2.95

SCOTTISH WONDER TALES FROM MYTH AND LEGEND, Donald A. Mackenzie. 16 lively tales tell of giants rumbling down mountainsides, of a magic wand that turns stone pillars into warriors, of gods and goddesses, evil hags, powerful forces and more. 240pp. 5⅜ x 8½. 29677-6 Pa. $6.95

THE HISTORY OF UNDERCLOTHES, C. Willett Cunnington and Phyllis Cunnington. Fascinating, well-documented survey covering six centuries of English undergarments, enhanced with over 100 illustrations: 12th-century laced-up bodice, footed long drawers (1795), 19th-century bustles, l9th-century corsets for men, Victorian "bust improvers," much more. 272pp. 5⅜ x 8¼. 27124-2 Pa. $9.95

ARTS AND CRAFTS FURNITURE: The Complete Brooks Catalog of 1912, Brooks Manufacturing Co. Photos and detailed descriptions of more than 150 now very collectible furniture designs from the Arts and Crafts movement depict davenports, settees, buffets, desks, tables, chairs, bedsteads, dressers and more, all built of solid, quarter-sawed oak. Invaluable for students and enthusiasts of antiques, Americana and the decorative arts. 80pp. 6½ x 9¼. 27471-3 Pa. $8.95

HOW WE INVENTED THE AIRPLANE: An Illustrated History, Orville Wright. Fascinating firsthand account covers early experiments, construction of planes and motors, first flights, much more. Introduction and commentary by Fred C. Kelly. 76 photographs. 96pp. 8¼ x 11. 25662-6 Pa. $8.95

THE ARTS OF THE SAILOR: Knotting, Splicing and Ropework, Hervey Garrett Smith. Indispensable shipboard reference covers tools, basic knots and useful hitches; handsewing and canvas work, more. Over 100 illustrations. Delightful reading for sea lovers. 256pp. 5⅜ x 8½. 26440-8 Pa. $7.95

FRANK LLOYD WRIGHT'S FALLINGWATER: The House and Its History, Second, Revised Edition, Donald Hoffmann. A total revision—both in text and illustrations—of the standard document on Fallingwater, the boldest, most personal architectural statement of Wright's mature years, updated with valuable new material from the recently opened Frank Lloyd Wright Archives. "Fascinating"—*The New York Times*. 116 illustrations. 128pp. 9¼ x 10¾. 27430-6 Pa. $11.95

PHOTOGRAPHIC SKETCHBOOK OF THE CIVIL WAR, Alexander Gardner. 100 photos taken on field during the Civil War. Famous shots of Manassas Harper's Ferry, Lincoln, Richmond, slave pens, etc. 244pp. 10⅝ x 8¼. 22731-6 Pa. $9.95

FIVE ACRES AND INDEPENDENCE, Maurice G. Kains. Great back-to-the-land classic explains basics of self-sufficient farming. The one book to get. 95 illustrations. 397pp. 5⅜ x 8½. 20974-1 Pa. $7.95

SONGS OF EASTERN BIRDS, Dr. Donald J. Borror. Songs and calls of 60 species most common to eastern U.S.: warblers, woodpeckers, flycatchers, thrushes, larks, many more in high-quality recording. Cassette and manual 99912-2 $9.95

A MODERN HERBAL, Margaret Grieve. Much the fullest, most exact, most useful compilation of herbal material. Gigantic alphabetical encyclopedia, from aconite to zedoary, gives botanical information, medical properties, folklore, economic uses, much else. Indispensable to serious reader. 161 illustrations. 888pp. 6½ x 9¼. 2-vol. set. (USO) Vol. I: 22798-7 Pa. $9.95
Vol. II: 22799-5 Pa. $9.95

HIDDEN TREASURE MAZE BOOK, Dave Phillips. Solve 34 challenging mazes accompanied by heroic tales of adventure. Evil dragons, people-eating plants, blood-thirsty giants, many more dangerous adversaries lurk at every twist and turn. 34 mazes, stories, solutions. 48pp. 8¼ x 11. 24566-7 Pa. $2.95

LETTERS OF W. A. MOZART, Wolfgang A. Mozart. Remarkable letters show bawdy wit, humor, imagination, musical insights, contemporary musical world; includes some letters from Leopold Mozart. 276pp. 5⅜ x 8½. 22859-2 Pa. $7.95

BASIC PRINCIPLES OF CLASSICAL BALLET, Agrippina Vaganova. Great Russian theoretician, teacher explains methods for teaching classical ballet. 118 illustrations. 175pp. 5⅜ x 8½. 22036-2 Pa. $5.95

THE JUMPING FROG, Mark Twain. Revenge edition. The original story of The Celebrated Jumping Frog of Calaveras County, a hapless French translation, and Twain's hilarious "retranslation" from the French. 12 illustrations. 66pp. 5⅜ x 8½. 22686-7 Pa. $3.95

BEST REMEMBERED POEMS, Martin Gardner (ed.). The 126 poems in this superb collection of 19th- and 20th-century British and American verse range from Shelley's "To a Skylark" to the impassioned "Renascence" of Edna St. Vincent Millay and to Edward Lear's whimsical "The Owl and the Pussycat." 224pp. 5⅜ x 8½. 27165-X Pa. $5.95

COMPLETE SONNETS, William Shakespeare. Over 150 exquisite poems deal with love, friendship, the tyranny of time, beauty's evanescence, death and other themes in language of remarkable power, precision and beauty. Glossary of archaic terms. 80pp. 5³⁄₁₆ x 8¼. 26686-9 Pa. $1.00

BODIES IN A BOOKSHOP, R. T. Campbell. Challenging mystery of blackmail and murder with ingenious plot and superbly drawn characters. In the best tradition of British suspense fiction. 192pp. 5⅜ x 8½. 24720-1 Pa. $6.95

AUTOBIOGRAPHY: The Story of My Experiments with Truth, Mohandas K. Gandhi. Boyhood, legal studies, purification, the growth of the Satyagraha (nonviolent protest) movement. Critical, inspiring work of the man responsible for the freedom of India. 480pp. 5⅜ x 8½. (USO) 24593-4 Pa. $8.95

CELTIC MYTHS AND LEGENDS, T. W. Rolleston. Masterful retelling of Irish and Welsh stories and tales. Cuchulain, King Arthur, Deirdre, the Grail, many more. First paperback edition. 58 full-page illustrations. 512pp. 5⅜ x 8½. 26507-2 Pa. $9.95

THE PRINCIPLES OF PSYCHOLOGY, William James. Famous long course complete, unabridged. Stream of thought, time perception, memory, experimental methods; great work decades ahead of its time. 94 figures. 1,391pp. 5⅜ x 8½. 2-vol. set.
Vol. I: 20381-6 Pa. $13.95
Vol. II: 20382-4 Pa. $14.95

THE WORLD AS WILL AND REPRESENTATION, Arthur Schopenhauer. Definitive English translation of Schopenhauer's life work, correcting more than 1,000 errors, omissions in earlier translations. Translated by E. F. J. Payne. Total of 1,269pp. 5⅜ x 8½. 2-vol. set.
Vol. 1: 21761-2 Pa. $12.95
Vol. 2: 21762-0 Pa. $12.95

MAGIC AND MYSTERY IN TIBET, Madame Alexandra David-Neel. Experiences among lamas, magicians, sages, sorcerers, Bonpa wizards. A true psychic discovery. 32 illustrations. 321pp. 5⅜ x 8½. (USO) 22682-4 Pa. $9.95

THE EGYPTIAN BOOK OF THE DEAD, E. A. Wallis Budge. Complete reproduction of Ani's papyrus, finest ever found. Full hieroglyphic text, interlinear transliteration, word-for-word translation, smooth translation. 533pp. 6½ x 9¼.
21866-X Pa. $11.95

MATHEMATICS FOR THE NONMATHEMATICIAN, Morris Kline. Detailed, college-level treatment of mathematics in cultural and historical context, with numerous exercises. Recommended Reading Lists. Tables. Numerous figures. 641pp. 5⅜ x 8½.
24823-2 Pa. $11.95

THEORY OF WING SECTIONS: Including a Summary of Airfoil Data, Ira H. Abbott and A. E. von Doenhoff. Concise compilation of subsonic aerodynamic characteristics of NACA wing sections, plus description of theory. 350pp. of tables. 693pp. 5⅜ x 8½.
60586-8 Pa. $14.95

THE RIME OF THE ANCIENT MARINER, Gustave Doré, S. T. Coleridge. Doré's finest work; 34 plates capture moods, subtleties of poem. Flawless full-size reproductions printed on facing pages with authoritative text of poem. "Beautiful. Simply beautiful."–*Publisher's Weekly.* 77pp. 9¼ x 12. 22305-1 Pa. $7.95

NORTH AMERICAN INDIAN DESIGNS FOR ARTISTS AND CRAFTSPEOPLE, Eva Wilson. Over 360 authentic copyright-free designs adapted from Navajo blankets, Hopi pottery, Sioux buffalo hides, more. Geometrics, symbolic figures, plant and animal motifs, etc. 128pp. 8⅜ x 11. (EUK) 25341-4 Pa. $8.95

SCULPTURE: Principles and Practice, Louis Slobodkin. Step-by-step approach to clay, plaster, metals, stone; classical and modern. 253 drawings, photos. 255pp. 8⅜ x 11.
22960-2 Pa. $11.95

THE INFLUENCE OF SEA POWER UPON HISTORY, 1660–1783, A. T. Mahan. Influential classic of naval history and tactics still used as text in war colleges. First paperback edition. 4 maps. 24 battle plans. 640pp. 5⅜ x 8½.　25509-3 Pa. $14.95

THE STORY OF THE TITANIC AS TOLD BY ITS SURVIVORS, Jack Winocour (ed.). What it was really like. Panic, despair, shocking inefficiency, and a little heroism. More thrilling than any fictional account. 26 illustrations. 320pp. 5⅜ x 8½.
20610-6 Pa. $8.95

FAIRY AND FOLK TALES OF THE IRISH PEASANTRY, William Butler Yeats (ed.). Treasury of 64 tales from the twilight world of Celtic myth and legend: "The Soul Cages," "The Kildare Pooka," "King O'Toole and his Goose," many more. Introduction and Notes by W. B. Yeats. 352pp. 5⅜ x 8½.　26941-8 Pa. $8.95

BUDDHIST MAHAYANA TEXTS, E. B. Cowell and Others (eds.). Superb, accurate translations of basic documents in Mahayana Buddhism, highly important in history of religions. The Buddha-karita of Asvaghosha, Larger Sukhavativyuha, more. 448pp. 5⅜ x 8½.　25552-2 Pa. $12.95

ONE TWO THREE . . . INFINITY: Facts and Speculations of Science, George Gamow. Great physicist's fascinating, readable overview of contemporary science: number theory, relativity, fourth dimension, entropy, genes, atomic structure, much more. 128 illustrations. Index. 352pp. 5⅜ x 8½.　25664-2 Pa. $8.95

ENGINEERING IN HISTORY, Richard Shelton Kirby, et al. Broad, nontechnical survey of history's major technological advances: birth of Greek science, industrial revolution, electricity and applied science, 20th-century automation, much more. 181 illustrations. ". . . excellent . . ."–Isis. Bibliography. vii + 530pp. 5⅜ x 8¼.
26412-2 Pa. $14.95

DALÍ ON MODERN ART: The Cuckolds of Antiquated Modern Art, Salvador Dalí. Influential painter skewers modern art and its practitioners. Outrageous evaluations of Picasso, Cézanne, Turner, more. 15 renderings of paintings discussed. 44 calligraphic decorations by Dalí. 96pp. 5⅜ x 8½. (USO)　29220-7 Pa. $4.95

ANTIQUE PLAYING CARDS: A Pictorial History, Henry René D'Allemagne. Over 900 elaborate, decorative images from rare playing cards (14th–20th centuries): Bacchus, death, dancing dogs, hunting scenes, royal coats of arms, players cheating, much more. 96pp. 9¼ x 12¼.　29265-7 Pa. $12.95

MAKING FURNITURE MASTERPIECES: 30 Projects with Measured Drawings, Franklin H. Gottshall. Step-by-step instructions, illustrations for constructing handsome, useful pieces, among them a Sheraton desk, Chippendale chair, Spanish desk, Queen Anne table and a William and Mary dressing mirror. 224pp. 8⅛ x 11¼.
29338-6 Pa. $13.95

THE FOSSIL BOOK: A Record of Prehistoric Life, Patricia V. Rich et al. Profusely illustrated definitive guide covers everything from single-celled organisms and dinosaurs to birds and mammals and the interplay between climate and man. Over 1,500 illustrations. 760pp. 7½ x 10¼.　29371-8 Pa. $29.95

Prices subject to change without notice.

Available at your book dealer or write for free catalog to Dept. GI, Dover Publications, Inc., 31 East 2nd St., Mineola, N.Y. 11501. Dover publishes more than 500 books each year on science, elementary and advanced mathematics, biology, music, art, literary history, social sciences and other areas.